Nashville
impressions

photography by Bob Schatz

FARCOUNTRY
PRESS

ABOVE: The scenes depicted on the Nashville Parthenon replicate those of the original in Athens, Greece. Nashville is known as the "Athens of the South" because of its numerous structures of classical design, as well as for its many colleges and universities.

RIGHT: The replica of the Parthenon was originally built in 1897 for Nashville's Centennial Exposition and is the centerpiece of Centennial Park. The monument in the foreground was built in honor of J. W. Thomas, leader of the Tennessee Centennial Exposition and president of the Louisville and Nashville Railroad.

TITLE PAGE: Once the elegant home of the Cheek family, the 55-acre Cheekwood Botanical Garden is visited by more than 190,000 visitors per year and features award-winning gardens, statuary, pools, fountains, and breathtaking views of the Tennessee hills.

FRONT COVER: Nashville's night lights draw bands of vivid color across the Cumberland River, and the 100-foot-tall *Ghost Ballet* sculpture adorns the east shore.

BACK COVER: Founders Pavilion, honoring Nashville founders James Robertson and John Donelson, sits on the 7.5-acre Public Square, located in front of Nashville's Metro Courthouse.

ISBN 10: 1-56037-375-X
ISBN 13: 978-1-56037-375-9
Photography © 2006 Bob Schatz
© 2006 Farcountry Press

For more information about our books write Farcountry Press, P.O. Box 5630, Helena, MT 59604; call (800) 821-3874; or visit www.farcountrypress.com.

Created, produced, and designed in the United States.
Printed in China.

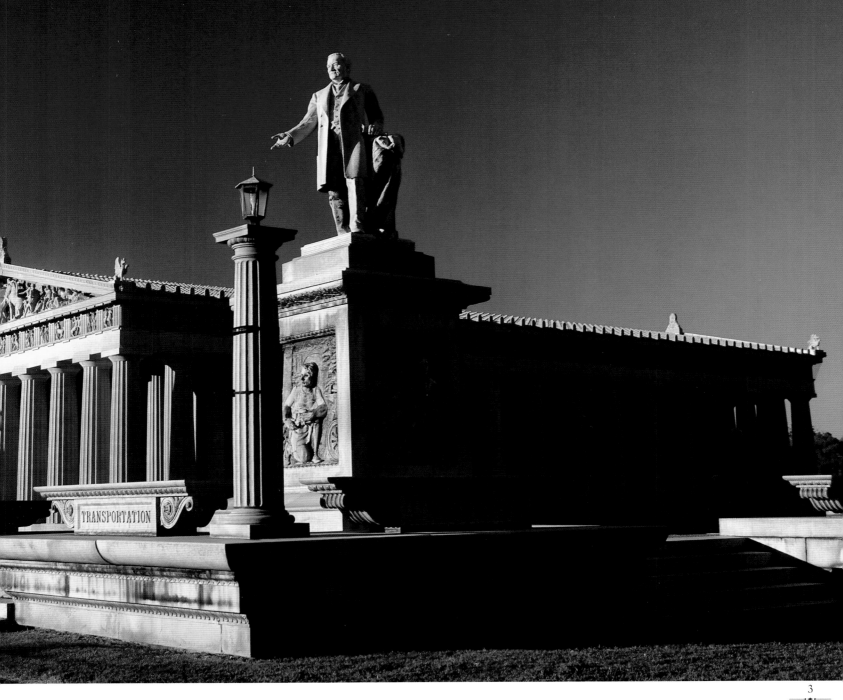

TRANSPORTATION

Foreword

by Bruce Dobie

Nashville writer and entrepreneur

Just before dawn, with guitar licks still ringing in their ears, the last of the musicians leave the stage. Chasing fame, six-figure record deals, and song lyrics to make their radio listeners cry, they now sip cold beers in a neon-infused parking lot outside another music club. Soon, they will head home. But with nothing else to do, they allow themselves this thought: today might make them famous.

Only a few miles away, down a hilly Nashville road, trainers enter horse stalls as the sun rises over a nearby hill. The Steeplechase race is one of Nashville's largest social occasions, and there's always work to do.

Meanwhile, in hole-in-the-wall restaurants throughout the city, short-order cooks begin beating out biscuits, boiling turnip greens, soaking pinto beans, cutting up catfish, and preparing to fuel the citizenry. Within hours, the patented cuisine of Nashville—so-called meat-and-three, or a choice of one meat and three vegetables—will feed a city.

As Nashville awakens, professional athletes commence their morning workouts; venture capitalists snap shut gold cufflinks; world-class laboratory scientists get the first inkling of what happened in the petri dish the night before. A few scattered farmers—a dwindling but hardy breed—head into their fields. Dozens of Mexican immigrants gather in parking lots in working-class neighborhoods to hire out for day labor. The political classes review the daily paper for clues to their destiny. The pot stirs.

The roads everywhere begin filling, growing as clogged as bad arteries. Commuters from the surrounding counties pour into the Nashville New South economic engine. The workers flow into the state capitol. They trek into the largest private health care company in the world, Hospital Corporation of America, and the city's fourteen colleges and universities, and its myriad record labels. The city becomes productive.

In the midst of it all, a determined friendliness rules. There is a healthy reservoir of Southern politeness in Nashville, even as the accents are increasingly East Coast, Asian, Hispanic. People wave to one another, say hi to strangers, and generally help even when it is not called for. It is a well-intended graciousness, not just a nicety offered up for the heck of it.

In the middle of the day, workers pour out onto the streets to grab their lunches, but not all of them seek food. Many go to church. It is not unusual for preachers in Nashville congregations to mount the pulpit for a little mid-day worship. Nashville is an extraordinarily religious city—The Buckle of the Bible Belt, as it is called.

Nashville's business classes are active, entrepreneurial, engaged. In an average Nashville afternoon, someone is conspiring to launch something; more often than not, that something is in the city's active health care industry. Other business sectors surge along as well, such as insurance, publishing, and finance.

Much of Nashville heads home at a fairly early hour, but one group does not. The music business is only beginning to rev its engines. By early evening, countless musicians hang their hopes on striking a label deal by performing try-out gigs at various clubs. More often than not, the Music Row executives are people from Los Angeles or New York. But it is to Nashville they return, because, frankly, they have grown to love it.

Visitors, like residents, also love the hills, the lakes, and the quaint farms that fan out from the city. They love how autumn blows your mind because the reds and golds are so intense, and how springtime is so precious it can make you giddy. Nashville was discovered long ago, and thousands came here to establish roots, but the discoverers never made it their own. Instead, they became Nashvillians, and preserved a very special place.

Photographer Bob Schatz understands these things about Nashville. And he captures the city's unique character in the engaging images that fill this book—a photographic tribute to Nashville.

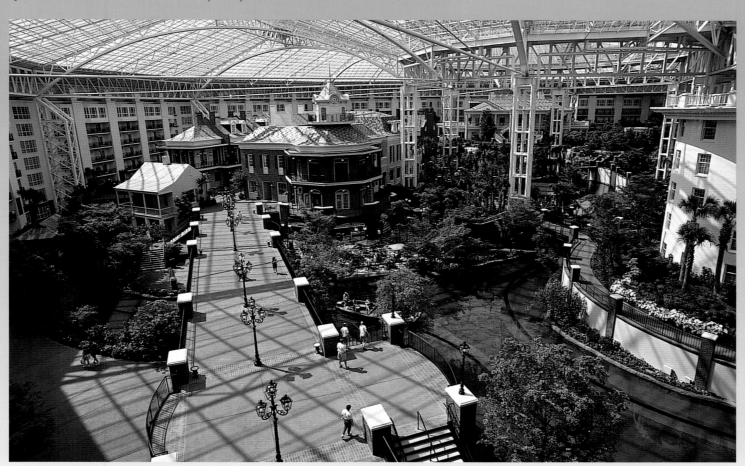

The Gaylord Opryland Hotel features nine acres of indoor gardens, rivers, pathways, and waterfalls contained in climate-controlled glass atriums.

RIGHT: Amid the Overton Hills, Radnor Lake provides habitat for numerous plant and animal species.

BELOW: Ballet dancers strike lovely poses at the edge of a sunlit pond in Cheekwood Botanical Garden. The Swan Ponds are a backdrop for many performances during the summer, including the Nashville Symphony.

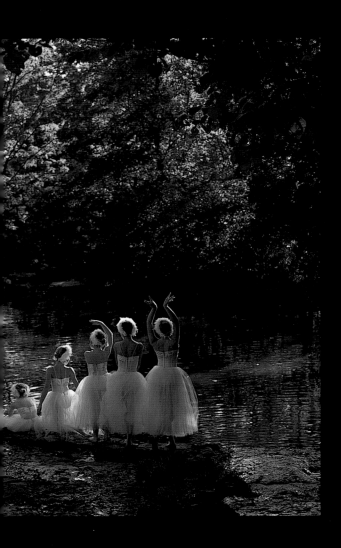

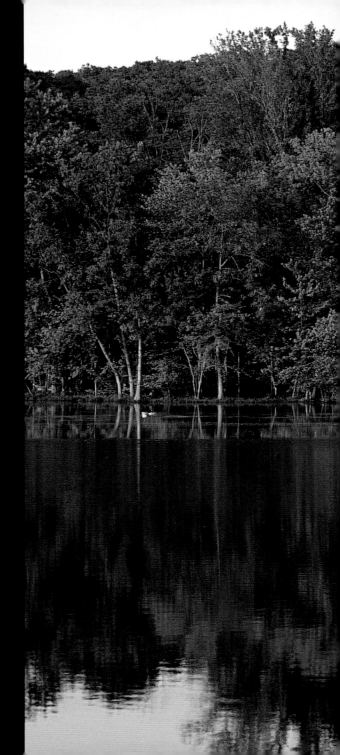

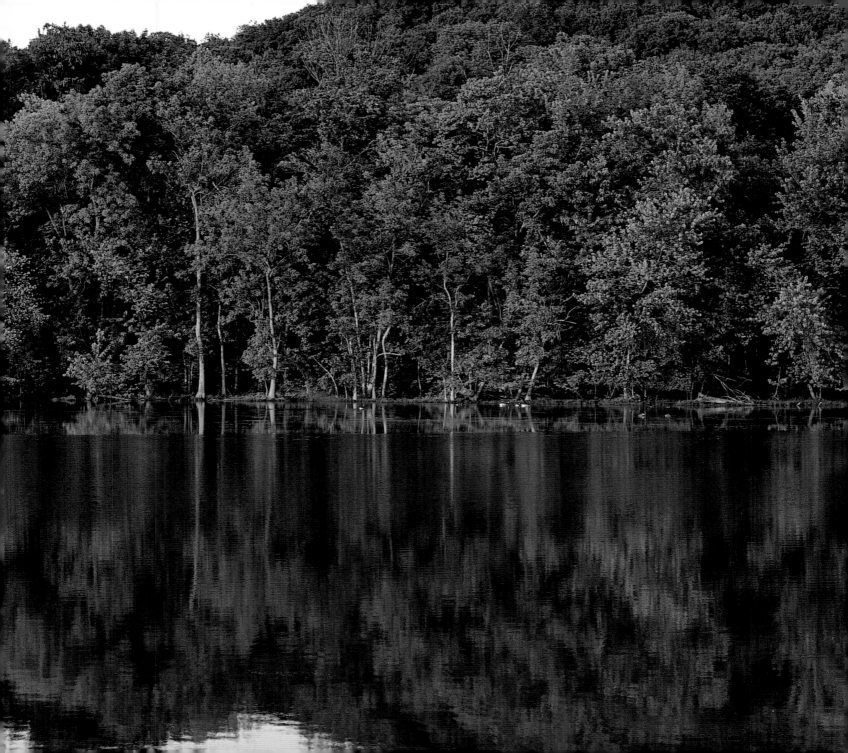

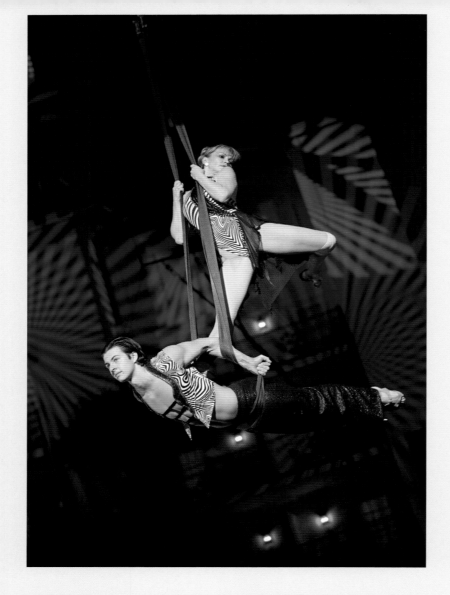

ABOVE: Aerialists perform under the soaring glass atrium of the Delta in the Gaylord Opryland Hotel during the annual Summerfest celebration.

RIGHT: March Madness fills the Gaylord Entertainment Center during rounds one and two of the NCAA Basketball Championships. The GEC is host to numerous sporting events and is home of the NHL Nashville Predators and the Arena Football League's Nashville Kats.

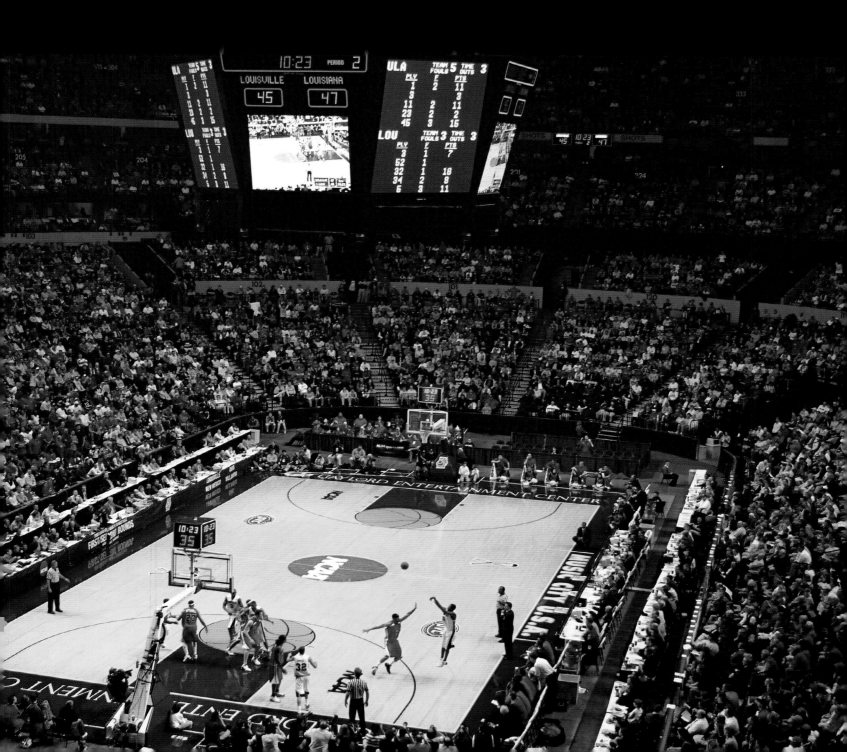

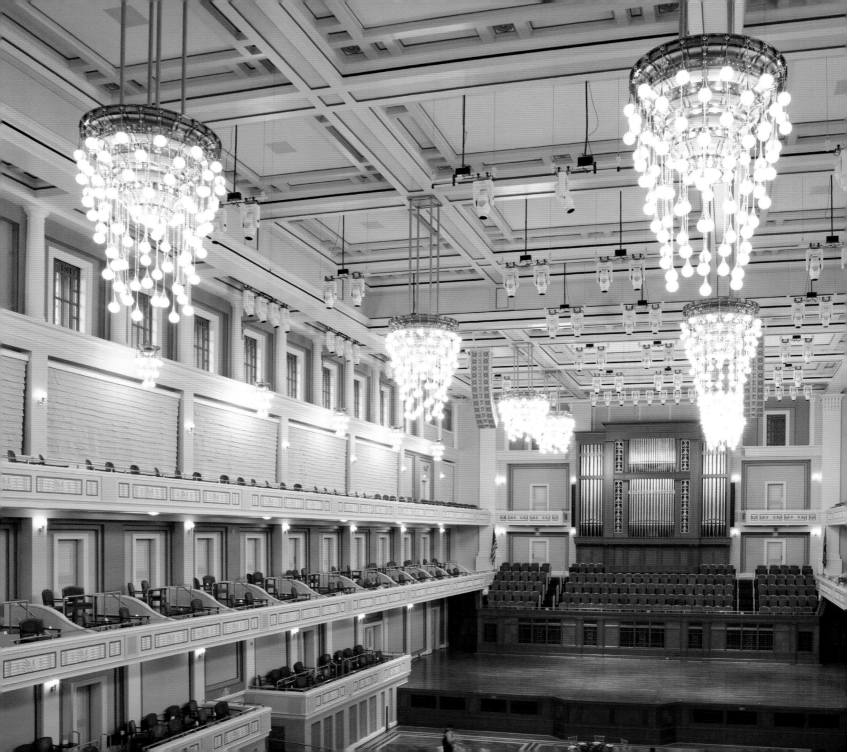

LEFT: Established in 1920, the Nashville Symphony performs in the spectacular Schermerhorn Symphony Center, named in honor of the late Maestro Kenneth Schermerhorn, who led the Grammy Award-winning Nashville Symphony for twenty-two years.

BELOW LEFT: Opened in 1900, Nashville's Union Station served the passenger needs of eight different railroads. It features a 65-foot vaulted ceiling of Tiffany stained glass. The building was renovated in 1984 and turned into a hotel.

BELOW RIGHT: An elegant staircase takes guests past stained-glass windows in the Neilson House, one of several preserved buildings in the historic East Nashville neighborhood of Edgefield.

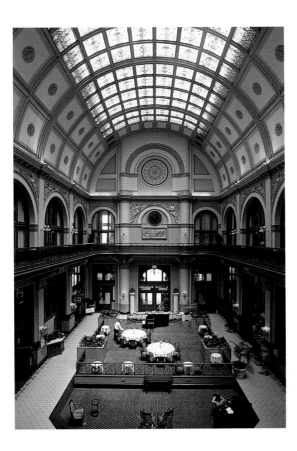

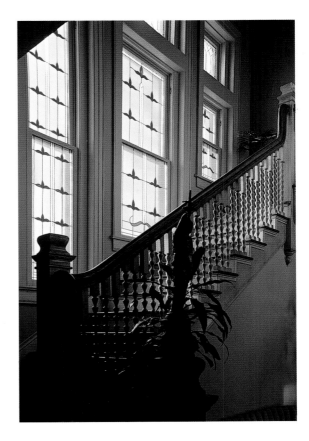

RIGHT: A sculpture of "found art" by Joe Sorci frames Nashville's skyline. He was commissioned by Greenways of Nashville to take rescued pieces from the Nashville Bridge Company and create public art.

BELOW: Businessmen walk to lunch from the SunTrust Financial Center.

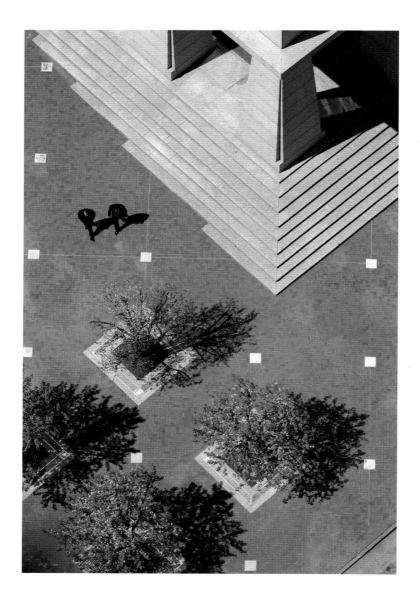

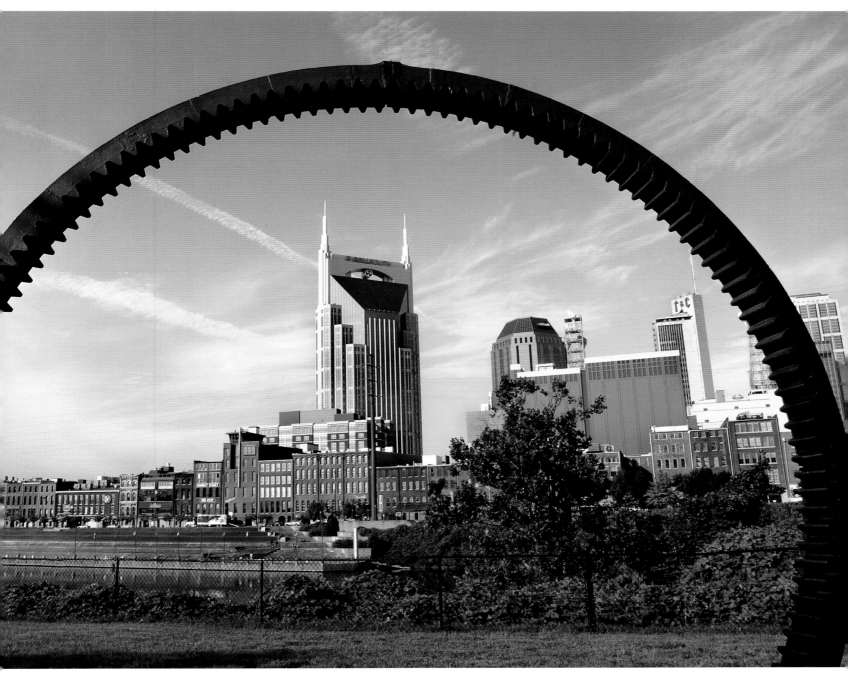

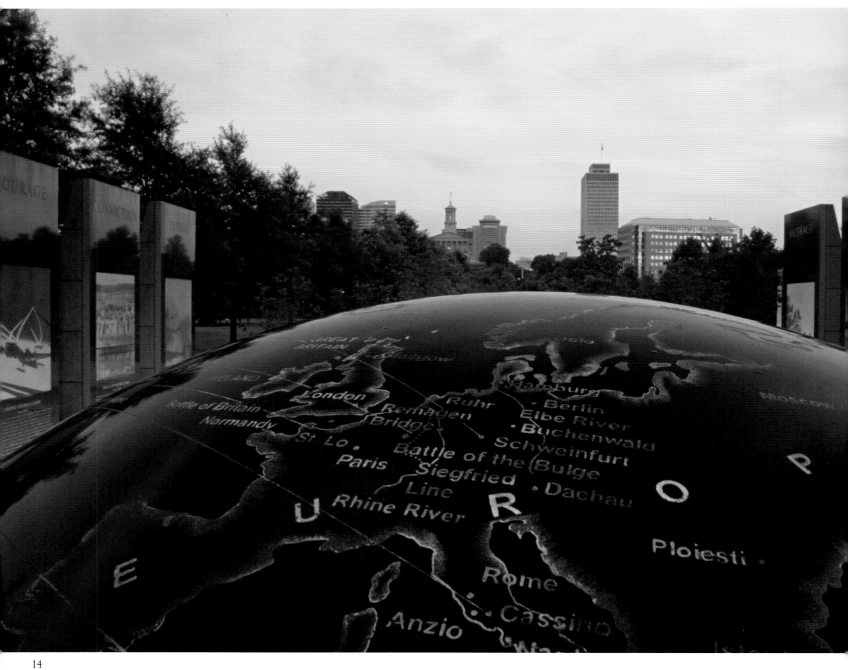

LEFT: The World War II Memorial features an 18,000-pound granite globe floating on water. It shows the mileage between Nashville and the different theaters of war. Various historic photographs are sandblasted into large granite markers flanking the globe.

BELOW: The Tennessee Titans, Nashville's first football team, play in the Nashville Coliseum, which seats more than 68,000 fans and is located on the east bank of the Cumberland River.

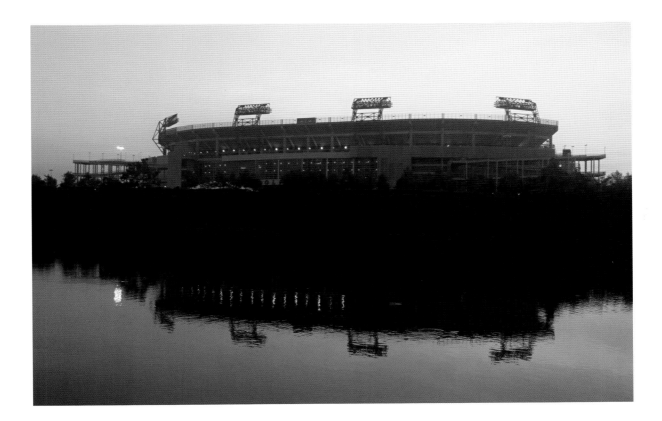

RIGHT: At nearly 42 feet in height, this replica of the Athena, Greek goddess of wisdom, was constructed inside Nashville's Parthenon from 1982 to 1990. In her right hand is a six-foot-four-inch statue of Nike, the goddess of victory. The large snake near her shield is believed to represent Erechtheus, a legendary king of Athens and symbol of Athenians who are protected by Athena.

FAR RIGHT: The Shelby Street Pedestrian Bridge illuminates the Cumberland River and is a favorite place for an evening stroll to view the Nashville skyline.

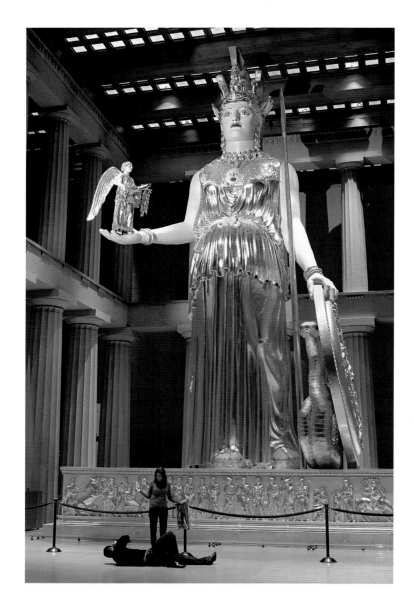

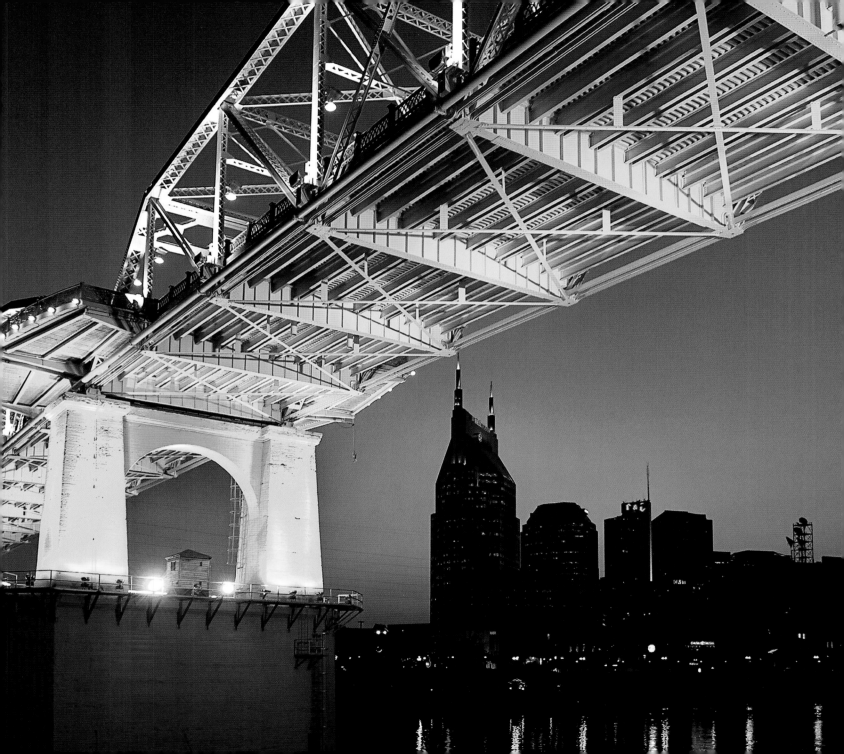

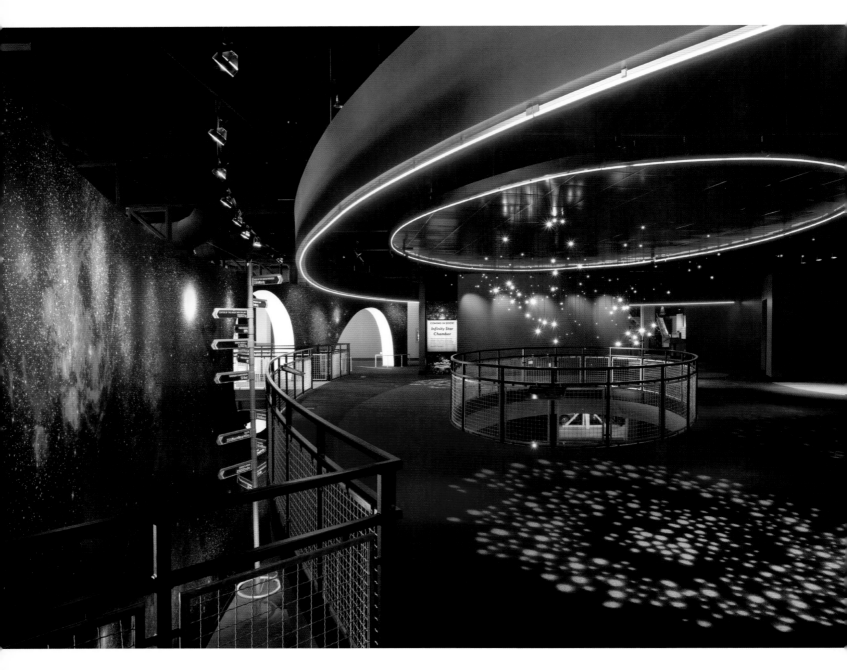

FACING PAGE: What began in 1944 as the Children's Museum of Nashville has grown into today's Adventure Science Center, home to a planetarium and dozens of exhibits that draw hundreds of thousands of visitors from throughout the region every year.

BELOW: The Hard Rock Cafe guitar sign, at the end of Broadway, and the BellSouth Tower reach toward the evening sky.

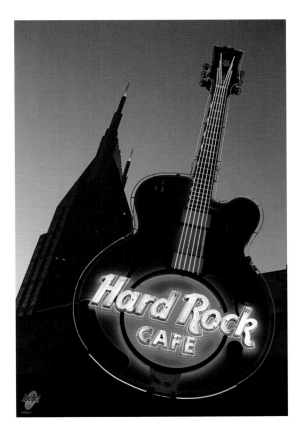

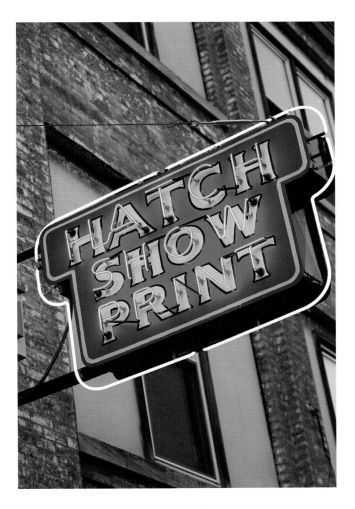

ABOVE: In 1875, William Hatch moved to Nashville with his two sons and started a printing shop on Broadway. Hatch Show Print became the premiere show-poster printer for everything, beginning with the circus, minstrel shows, vaudeville acts, and carnivals. They became most famous when they began to print posters for all the Opry stars. Though the shop has become part of the Country Music Hall of Fame, it is still in operation today, printing for clients such as Bruce Springsteen, Bob Dylan, and many others.

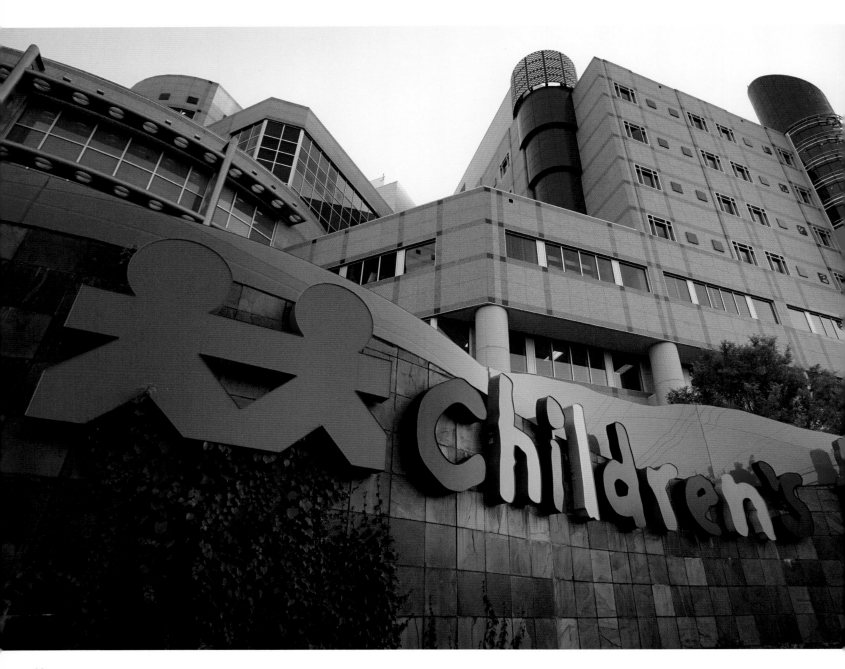

LEFT: Many children are treated at the Monroe Carell Jr. Children's Hospital at Vanderbilt, a non-profit teaching and research hospital.

BELOW: Hillsboro Village has been revitalized and is now a shopping district full of trendy shops and restaurants, in addition to many of the original businesses. Behind this decorative cornice and American flag is The Villager, a longtime watering hole for Vanderbilt students and locals alike.

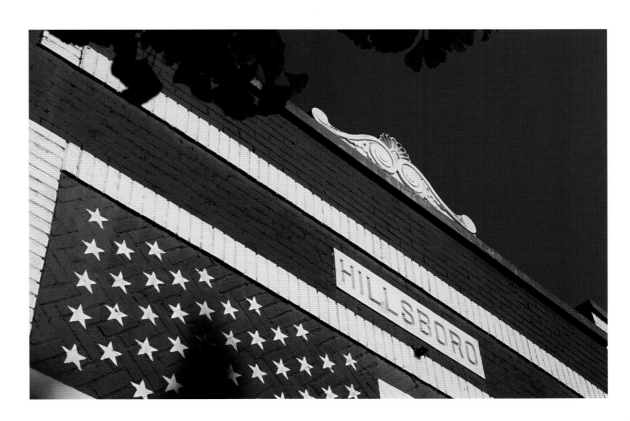

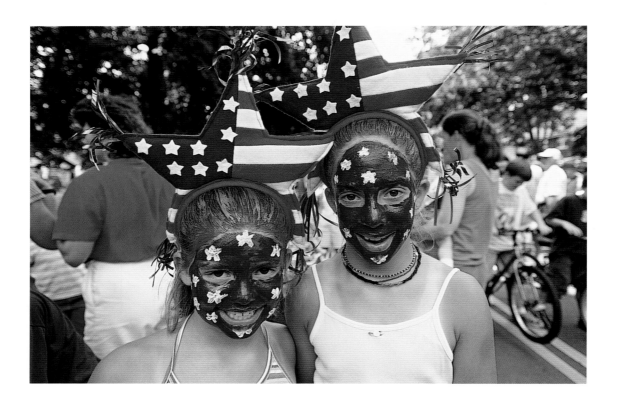

ABOVE: Two friends show their patriotism at the annual Fourth of July parade in the Whitland area, one of Nashville's most attractive historic neighborhoods.

RIGHT: The Lock 4 Challenge mountain-bike race takes place in Lock 4 City Park, which features almost 20 miles of single-track trail at the edge of Old Hickory Lake.

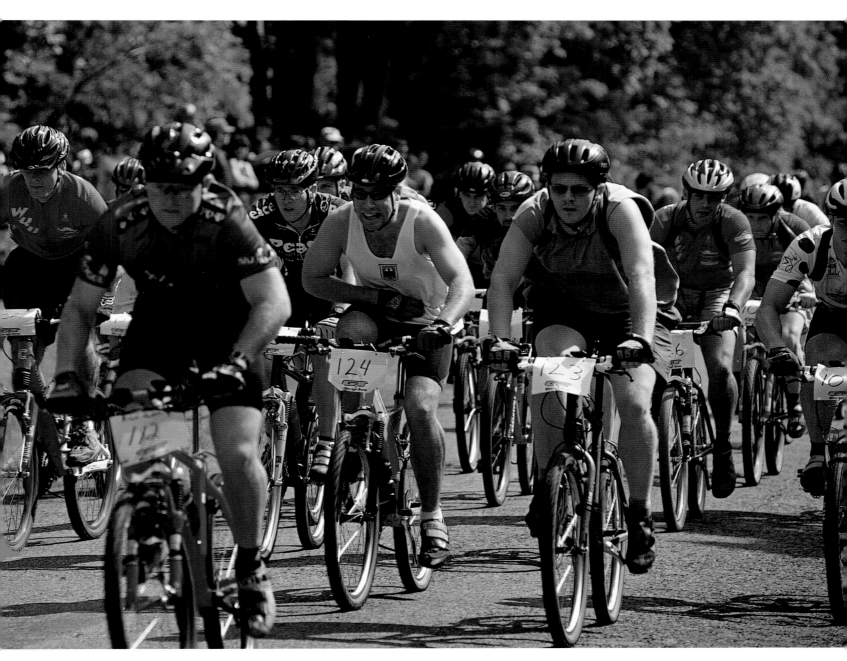

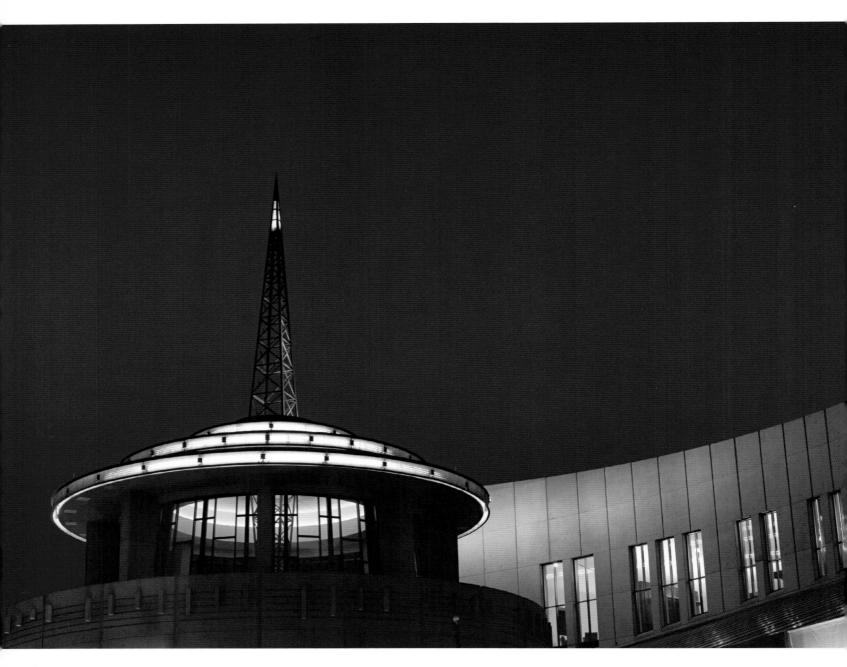

LEFT: Known as Music City, U.S.A., Nashville is home of the Country Music Hall of Fame, located on the west bank of the Cumberland River near the historic Ryman Auditorium and the honky tonks of Lower Broadway.

RIGHT AND BELOW: Dusk casts a violet hue on the fountain and grand entrance of the Metro Courthouse. Opened for the first time in 1937, the art deco Metro Courthouse is home of the mayor's office, the Metro Council, and a number of courts.

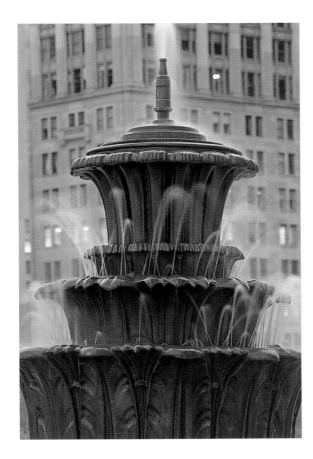

FACING PAGE: A couple strolls through the Herb Garden in the Cheekwood Botanical Garden. The limestone columns are from the Tennessee state capitol.

RIGHT: This playful statue is one of many on the Cheekwood grounds.

BELOW: Magnolias blossom in Cheekwood's lush flower gardens.

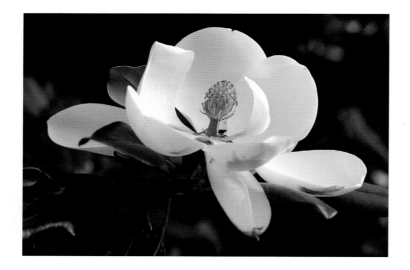

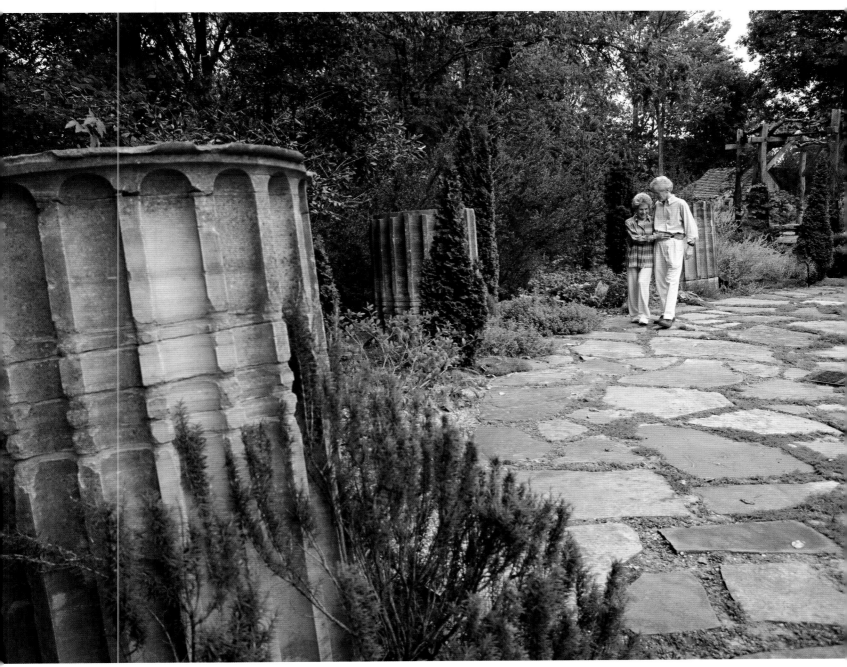

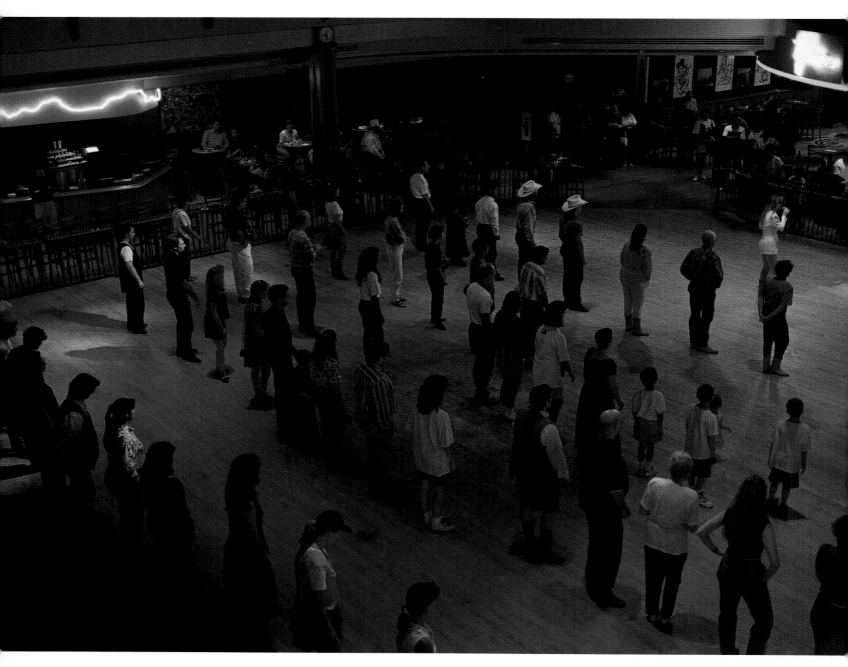

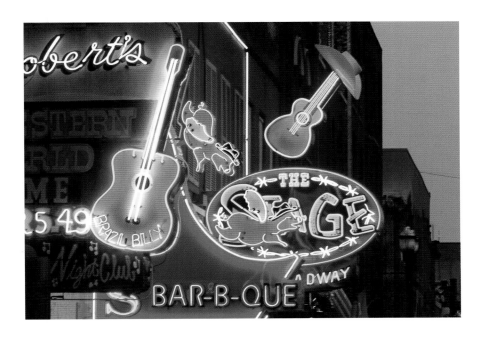

ABOVE: Neon signs light up historic Broadway.

LEFT: Line dancers kick up their boots on the dance floor at the Wild Horse Saloon, famous for its live country music and Southern cuisine.

RIGHT: Katy K Design in the Twelfth South District carries everything Western, from cowboy boots to vintage embroidered skirts and shirts.

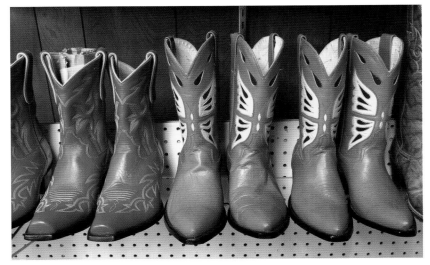

RIGHT: An old bridge abutment succumbs to time and the elements at Richland Creek. This is all that remains of a stretch of railroad track where the worst train wreck in U.S. history occurred. In July 1918, 101 people died when Train No. 4 went around the curve too fast and left the track. The Richland Creek Greenway now runs along this same path.

FAR RIGHT: Bison graze at the Nashville Zoo. The zoo features animals from around the world and offers many educational programs for visitors.

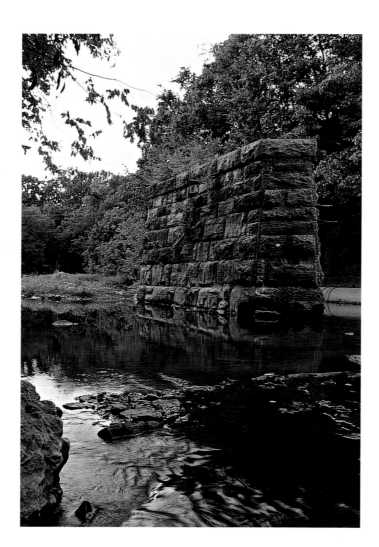

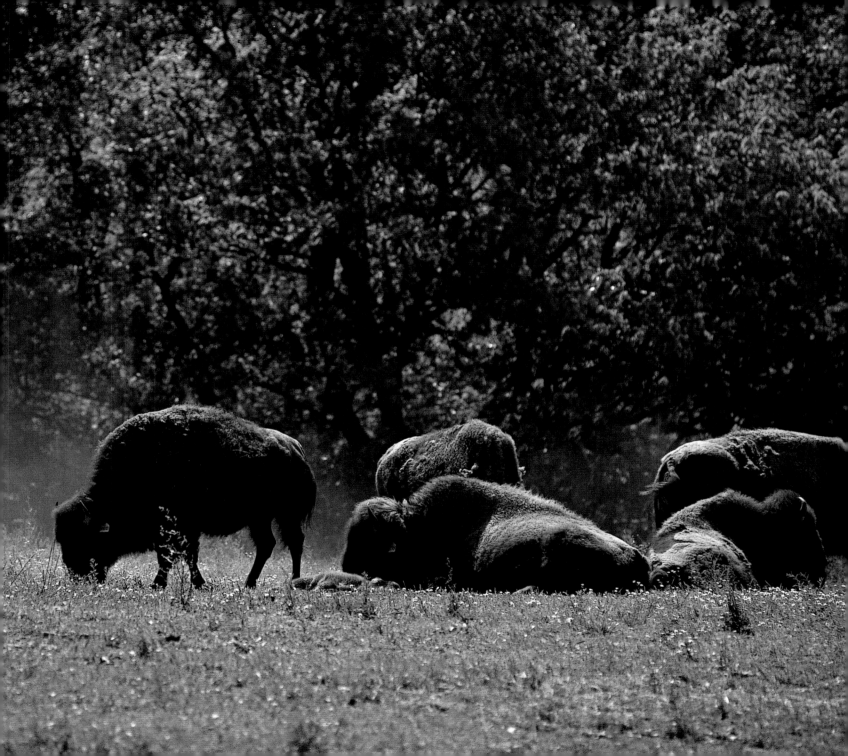

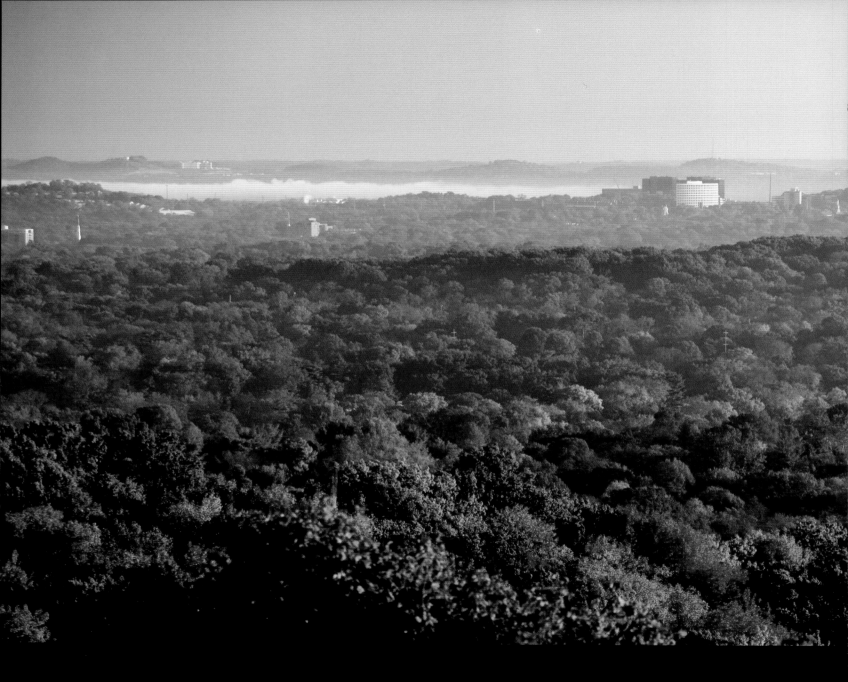

The view from Flat Pole Hill in Percy Warner Park shows the virtual ocean of trees that surrounds Nashville's city center.

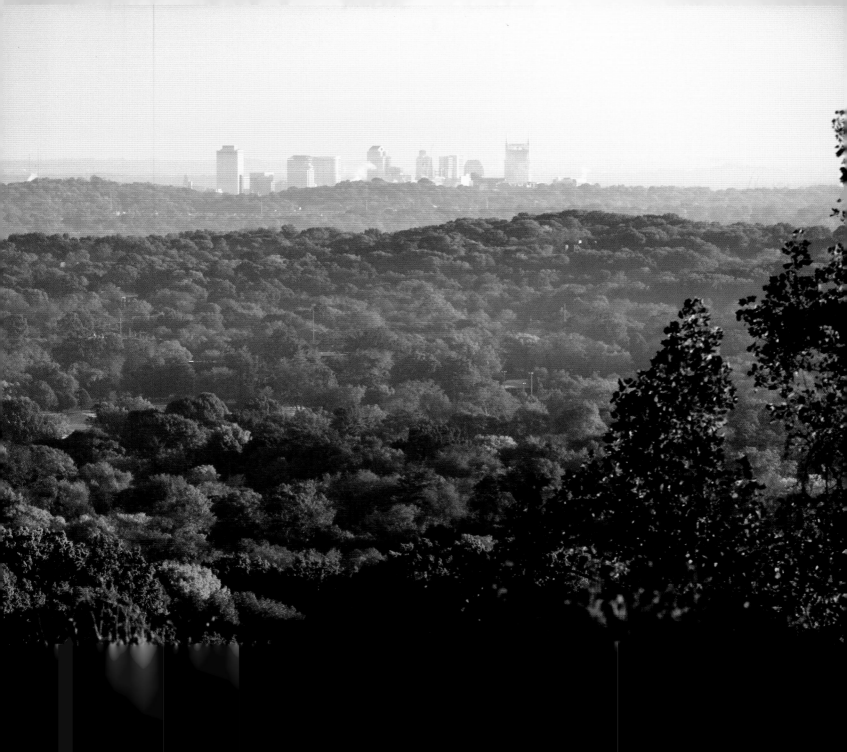

RIGHT: Completed in 1859, the state capitol is located on a hill in downtown Nashville. The distinctive tower was designed to resemble the monument of Lysicrates in Athens, Greece. William Strickland, the capitol's designer, died before construction was completed and, according to his wishes, he was buried in the walls of the capitol. His tomb is visible at the northeast corner of the building near the north entrance.

BELOW: Adelicia Acklen purchased this striking statue during her grand tour of Europe following the Civil War. It reminded her of her twins, who died of scarlet fever. The marble statue is displayed at Belmont, Acklen's nineteenth-century, Italianate villa that is open for tours.

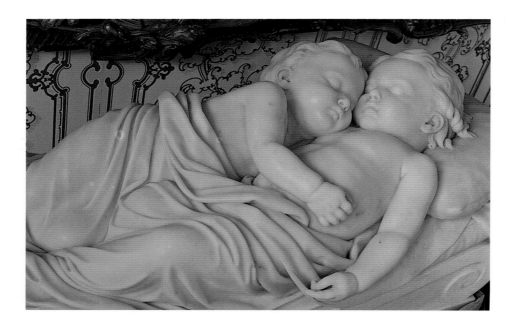

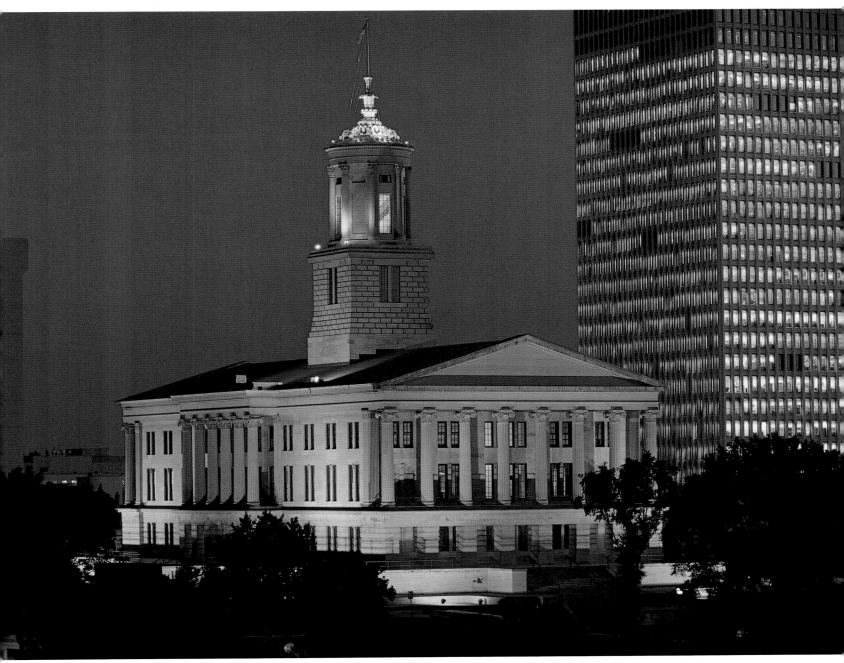

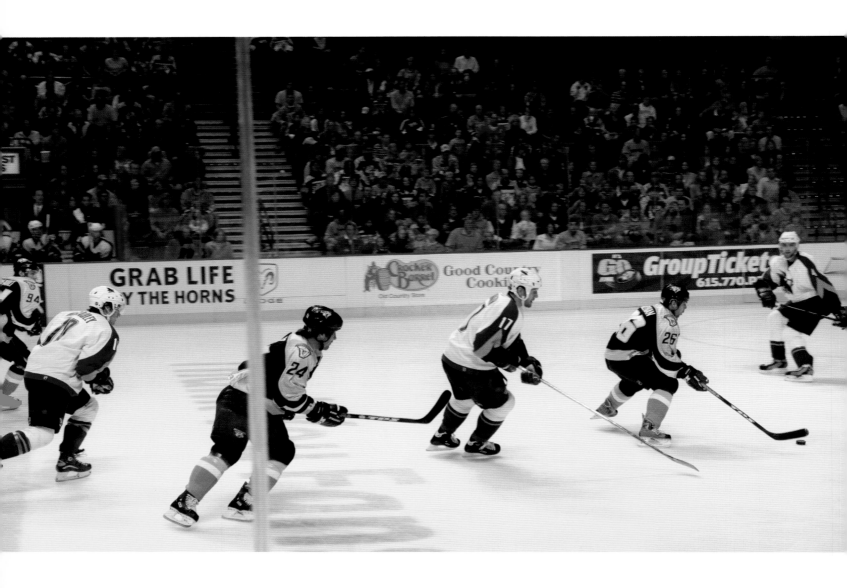

LEFT: The Nashville Predators hockey team takes to the ice at Gaylord Entertainment Center. Established in 1998, the team's mascot is Gnash, a saber-toothed cat. During the excavation of a Nashville-area cave in 1971, the fossilized bones of a saber-toothed cat, a species extinct for at least 10,000 years, were found. The fossil is only the fifth of its kind found in North America.

BELOW: A stock car lines up in the pit area for a time trial at the Nashville Super Speedway.

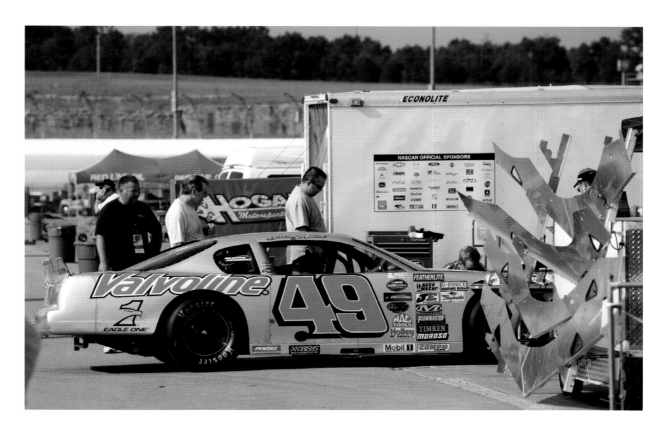

RIGHT: In 1951, Annie and Lon Loveless began serving their famous fried chicken and biscuits. The Loveless Motel and Café underwent a total renovation in 2004 to better serve the thousands that flock there to taste the original, secret recipe.

BELOW: Nashville's popular Farmers Market, established in 1828, is a great place to find fresh produce and flowers.

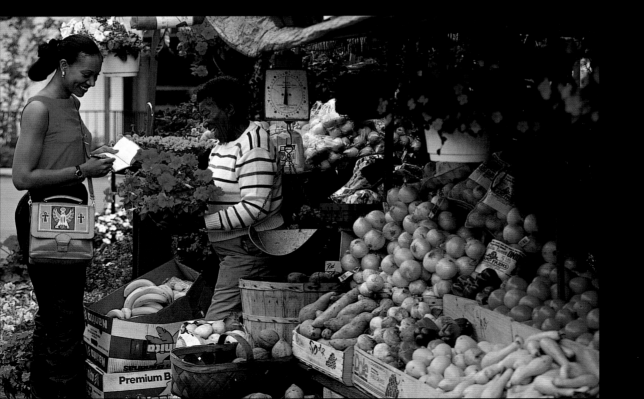

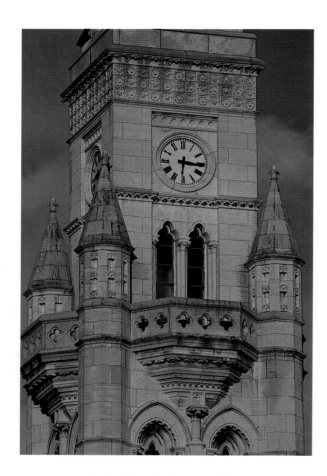

ABOVE LEFT: A detail of the clock tower of the Customs House, which is now home to the Federal Bankruptcy Court.

ABOVE RIGHT: Nashville was founded as "Fort Nashborough" by James Robertson and John Donelson (Robertson arrived in 1779 and Donelson in 1780). Statues of these two men stand in Riverfront Park. Fort Nashborough was renamed Nashville in 1784 and became the capital of Tennessee in 1843.

FAR RIGHT: The Opryland Museum entrance was built to resemble the alley behind the original home of the Grand Ole Opry, the historic Ryman Auditorium.

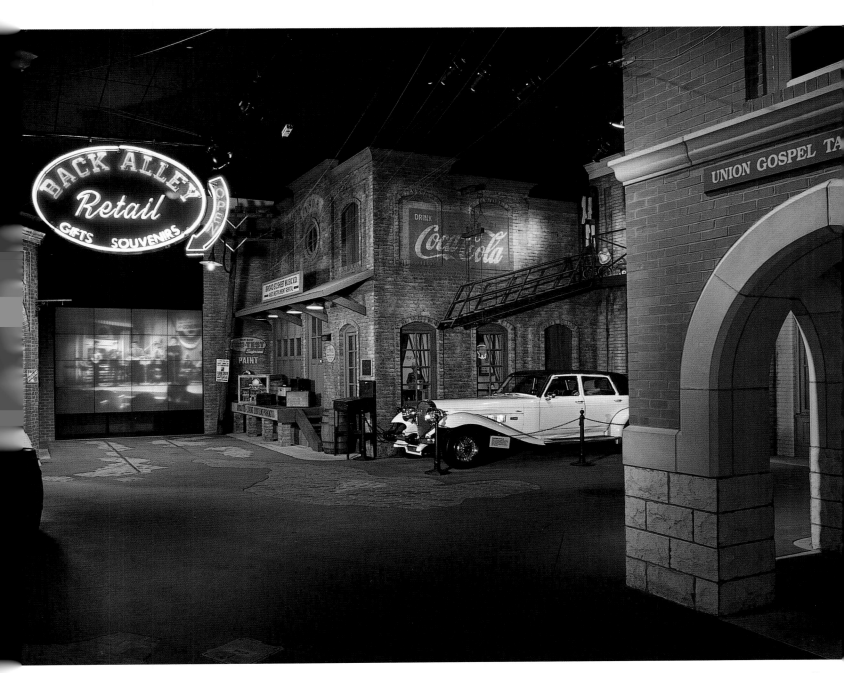

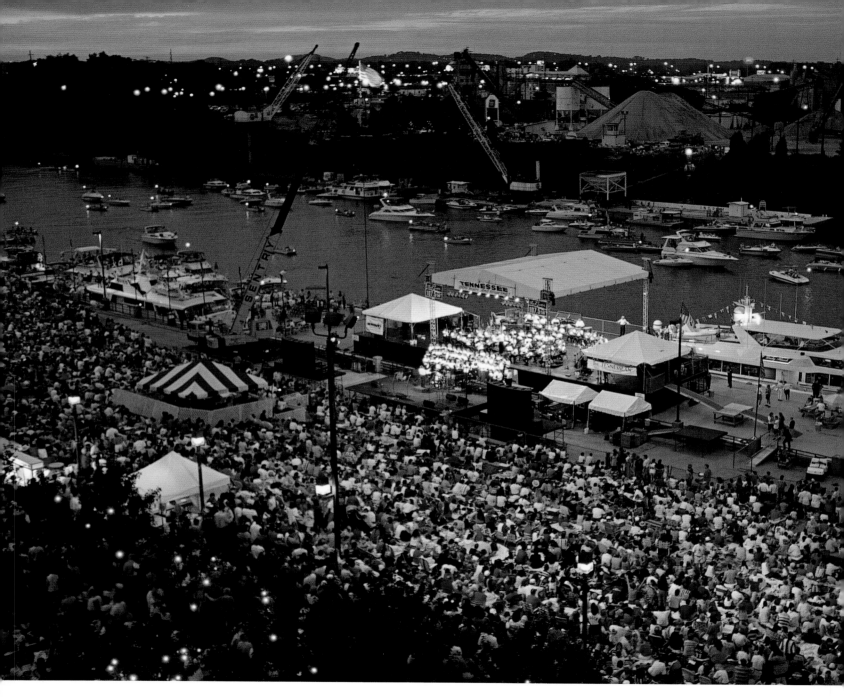

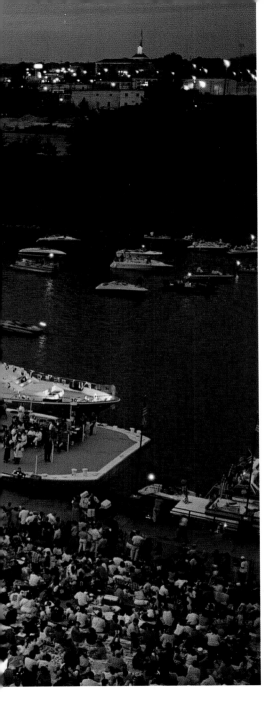

LEFT: An enthusiastic crowd gathers at the Cumberland River to take in the sweet sounds of the Nashville Symphony during their annual Fourth of July fireworks concert.

BELOW: The tower of the Gaylord Entertainment Center marks its main entrance just off Broadway.

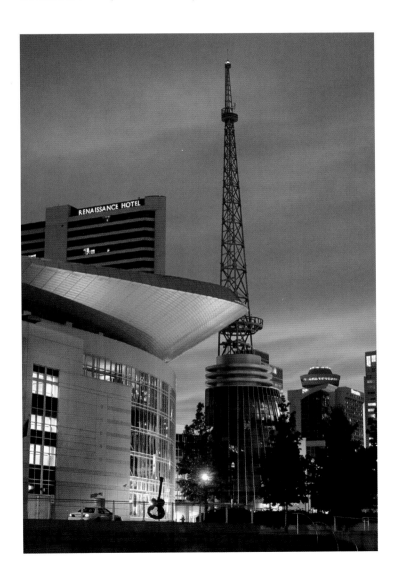

RIGHT: The Iroquois Steeplechase has run continuously since 1941 (with the exception of 1945, when the race was suspended because of World War II) at Percy Warner Park on a course designed by William DuPont.

BELOW: Nashville's 13-acre Elmington Park hosts a variety of events, including lacrosse and Australian football tournaments.

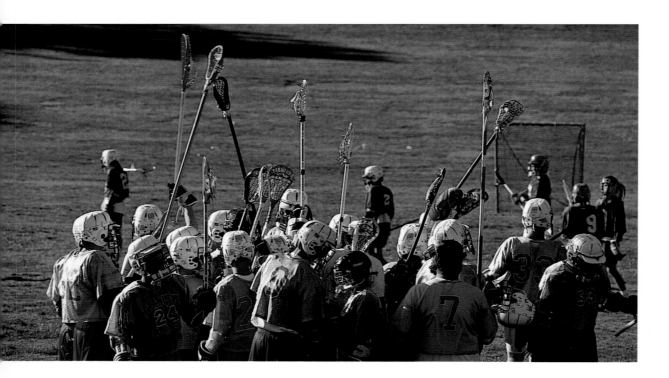

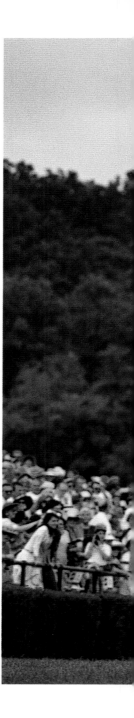

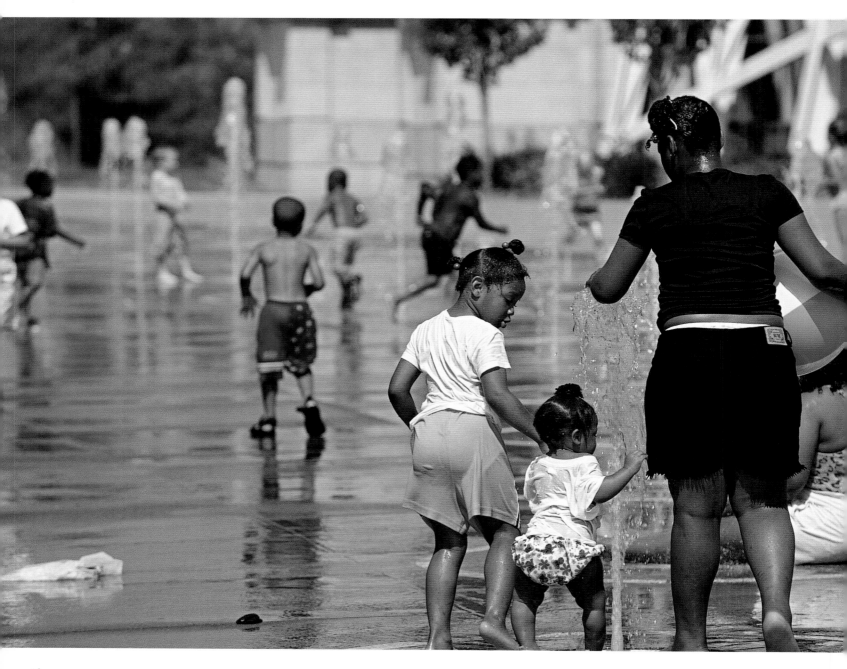

RIGHT: Actors portray Porter Wagner and Minnie Pearl in the plaza outside the Ryman Auditorium.

LEFT: Children play in the fountains at the Bicentennial Capitol Mall State Park, a 19-acre park located in the shadow of the state capitol in downtown Nashville.

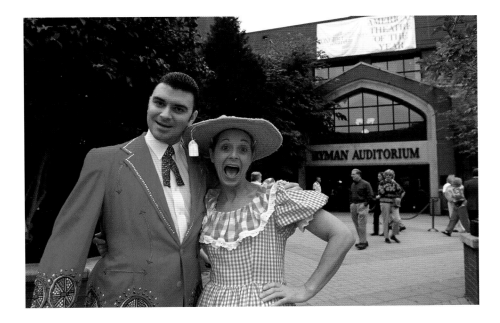

RIGHT: Catfish Out of Water was a public art project designed to raise awareness of the importance of protecting and enhancing the Cumberland River, a valuable natural resource. More than 50 catfish sculptures swam through Nashville's public gathering spots in 2003, and many are still displayed throughout the city.

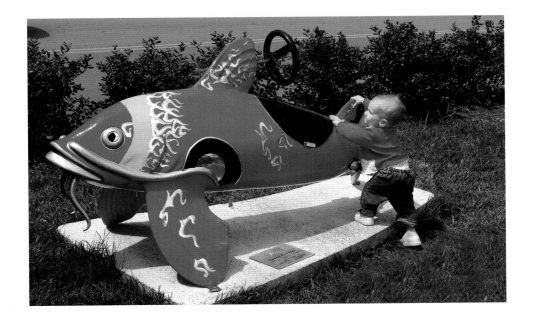

RIGHT: In addition to the state capitol, architect William Strickland designed the Downtown Presbyterian Church, formerly First Presbyterian Church. Completed in 1851, the church is noted for its distinctive Egyptian Revival architecture.

BELOW: Gilt-frame mirrors hang over original marble mantels, including this one in the entryway, in the elegantly appointed Belmont Mansion. Much of the furniture and art is original to the mansion.

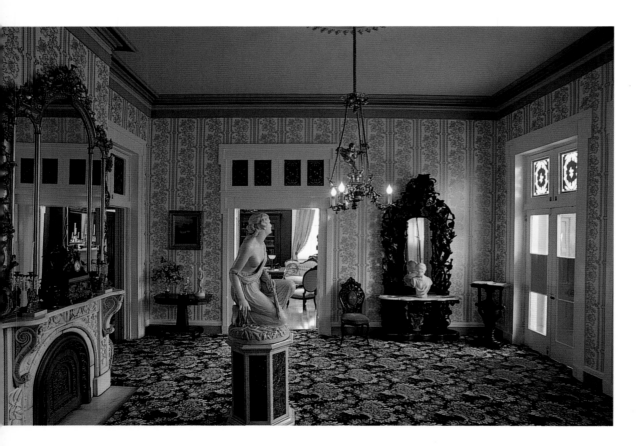

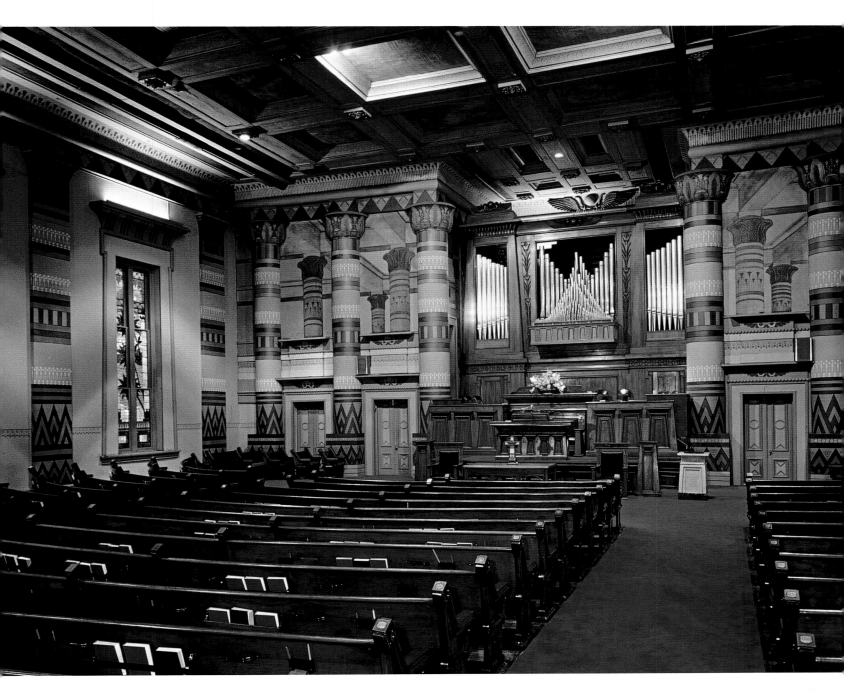

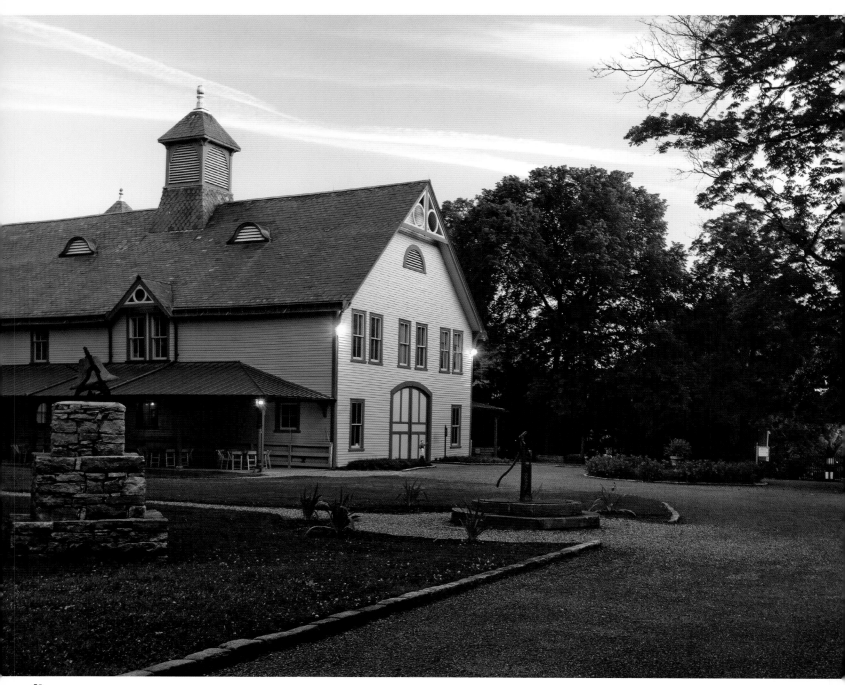

LEFT: The restored stables of Belle Meade Plantation, the "Queen of Tennessee Plantations," were once home to a world-renowned thoroughbred farm. The plantation also served as Confederate General James R. Chalmers' headquarters during the Battle of Nashville in 1864.

BELOW: One of many beautiful golf courses in the Nashville area, Harpeth Hills beckons visitors to its manicured greens.

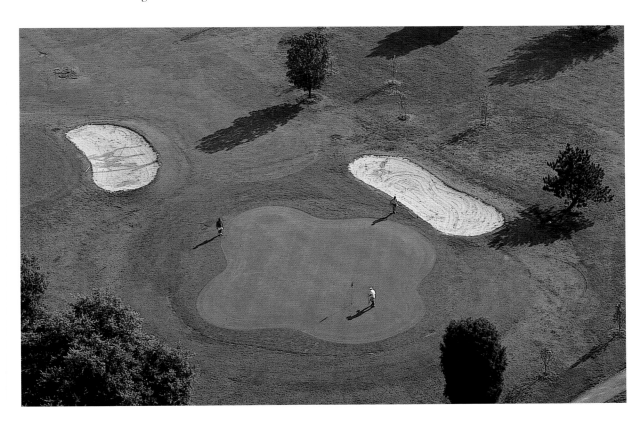

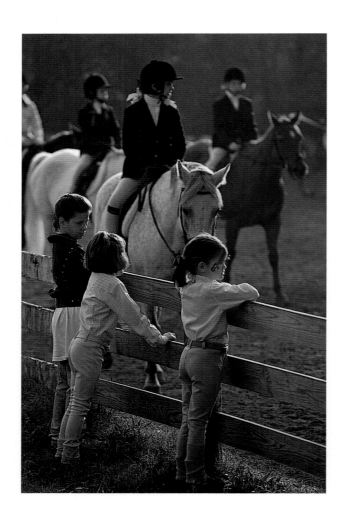

FACING PAGE: Geese swim through the waters of Lake Watauga in Centennial Park, the image of the Parthenon reflected in its rippled surface.

LEFT AND BELOW: Young riders participate in the Oak Hill Horse Show at the Ellington Agricultural Center.

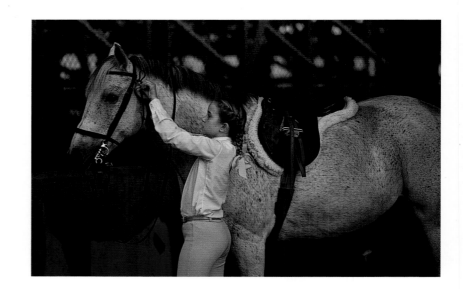

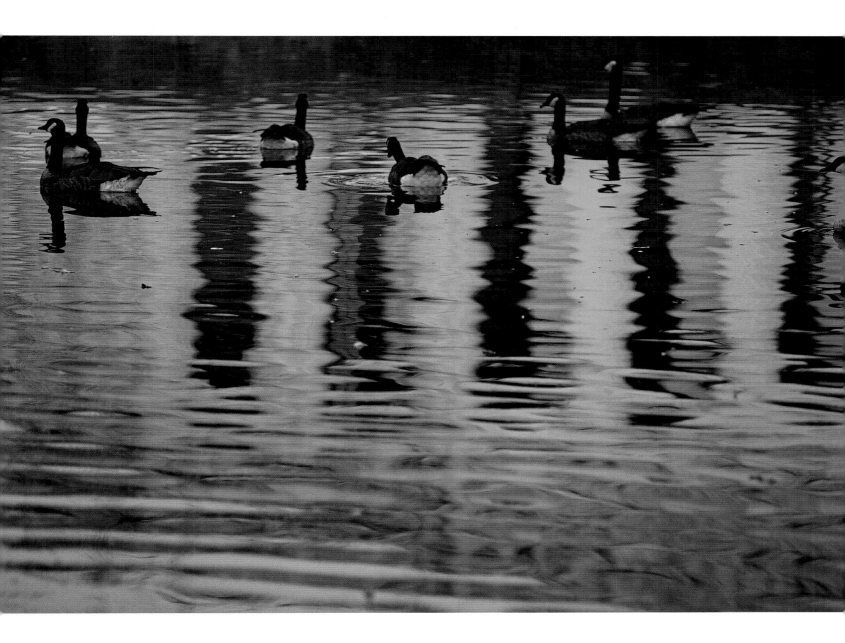

LEFT: The Country Music Hall of Fame offers a visual history of country music and houses an extensive collection of memorabilia and early recordings.

BELOW: The Arts Company, in the Fifth Avenue Arts District, showcases contemporary art from Nashville and around the nation.

RIGHT: *Musica,* a large-scale sculpture by Nashvillian Alan LeQuire, dances above the Music Row Roundabout. It has become the centerpiece of the rebirth of Music Row.

BELOW RIGHT: These stone gates engraved with Vs mark the entrance to the Vanderbilt University campus. The university is named after its benefactor, Commodore Cornelius Vanderbilt.

FAR RIGHT: Representing Tennessee's musical heritage, the 95-bell carillon anchors the northern end of the Bicentennial Mall. A 96th bell, known as the answer bell, is located on the grounds of the state capitol and rings in answer to the 95 bells, symbolizing government answering to the people.

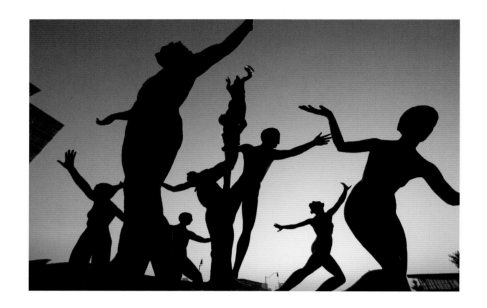

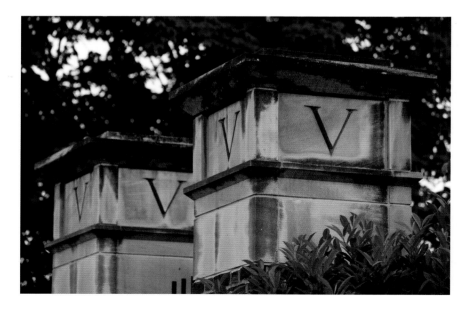

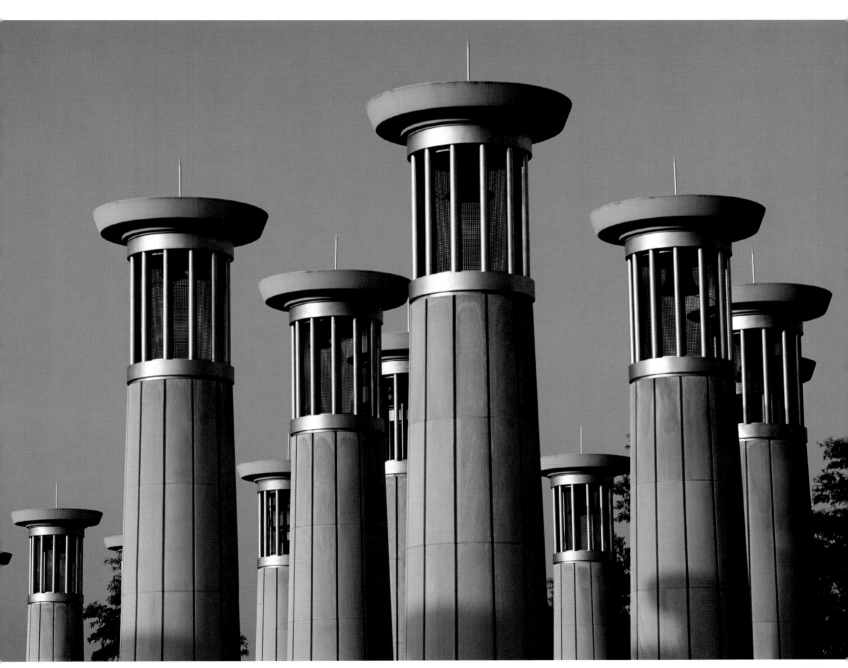

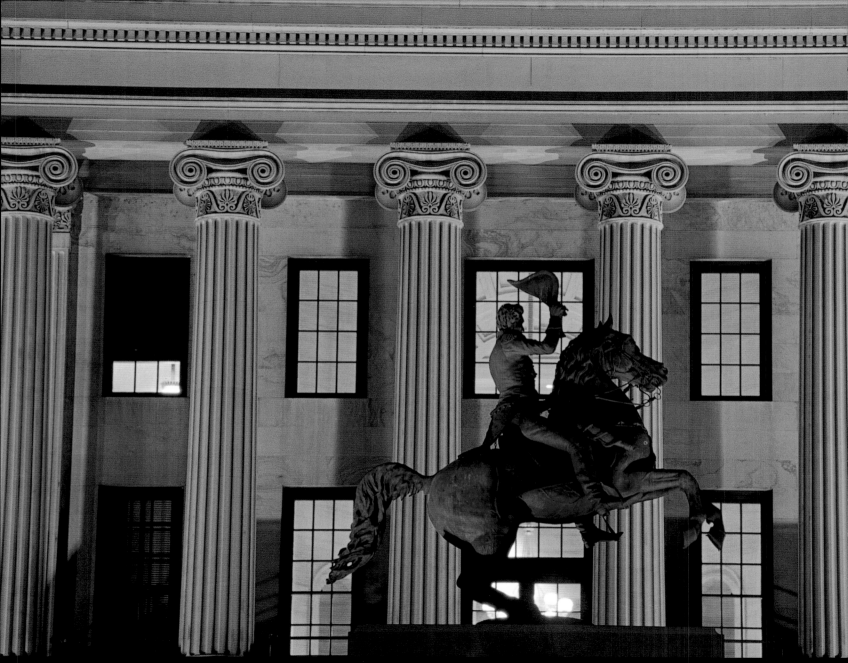

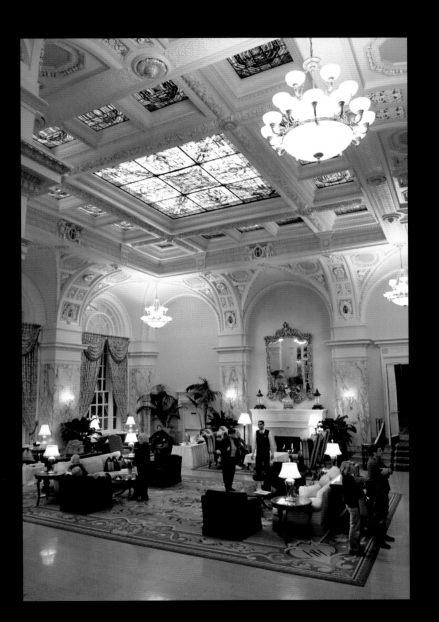

LEFT: Opening its doors in 1910, the Hermitage Hotel was recently renovated and became Tennessee's only Mobil Five Star Hotel.

FAR LEFT: Outside the state capitol stands a bronze statue of Andrew Jackson the seventh President of the United States. Although Jackson was born in South Carolina, he was the first person elected from Tennessee to the House of Representatives, and he served briefly in the Senate. During the War of 1812, Jackson became a national hero when he defeated the British at New Orleans. A copy of this same statue can be found in Jackson Square in New Orleans.

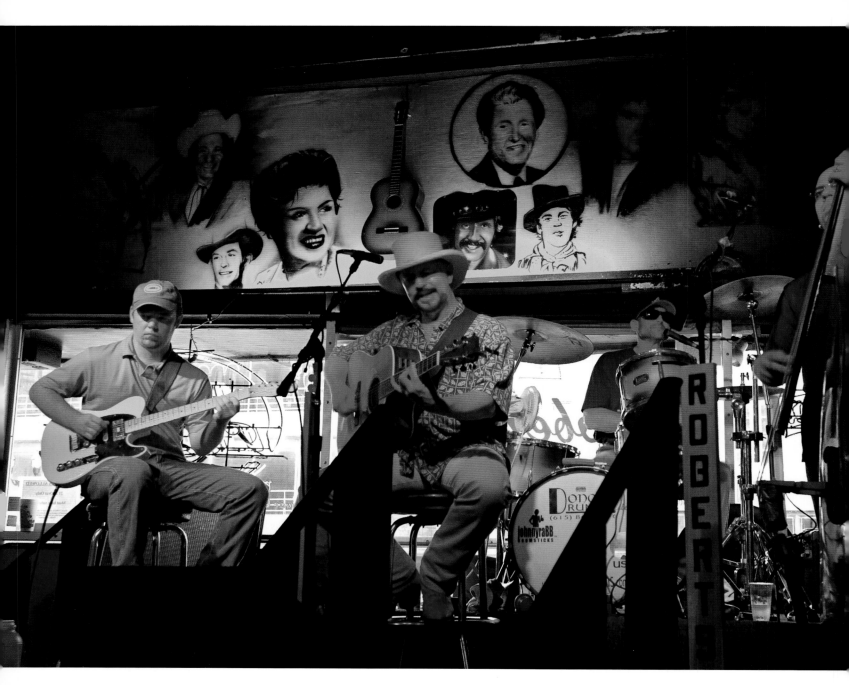

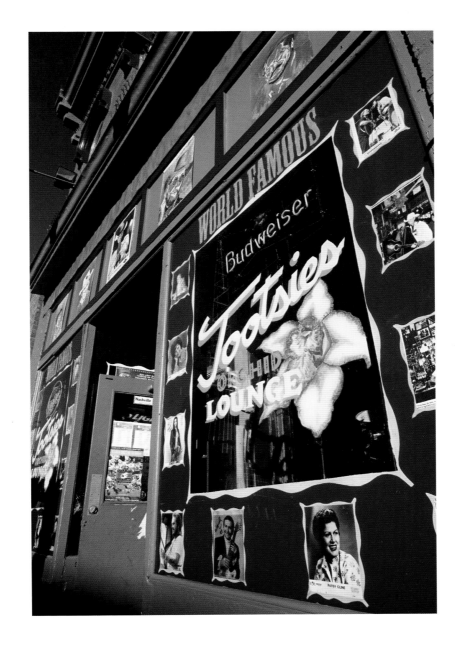

LEFT: Tootsie's Orchid Lounge became famous because of its convenient location across the alley from the Ryman Auditorium's stage door. Many Opry stars were discovered when they played on stage here, and many more will begin their careers here.

FAR LEFT: Robert's Western World is one of many honky tonks along Broadway. Some of the most adored country music stars have graced its stages, from Merle Haggard to Allison Kraus.

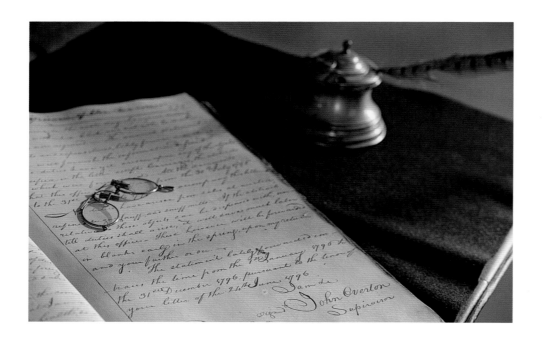

ABOVE: This ledger was signed by John Overton, original owner of Travellers Rest, a 1799 home in Nashville that is now on the National Register of Historic Places. Overton was a member of the state Supreme Court and a close personal friend of President Andrew Jackson.

RIGHT: Choreographed to music, colorful lights illuminate the dancing waters of the Delta fountains at the Gaylord Opryland Hotel.

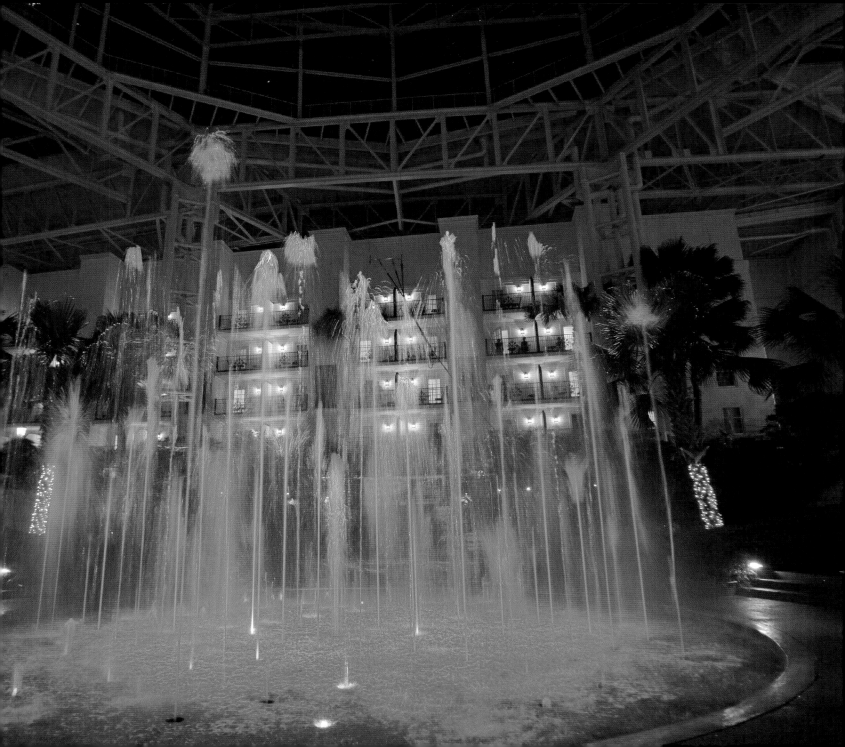

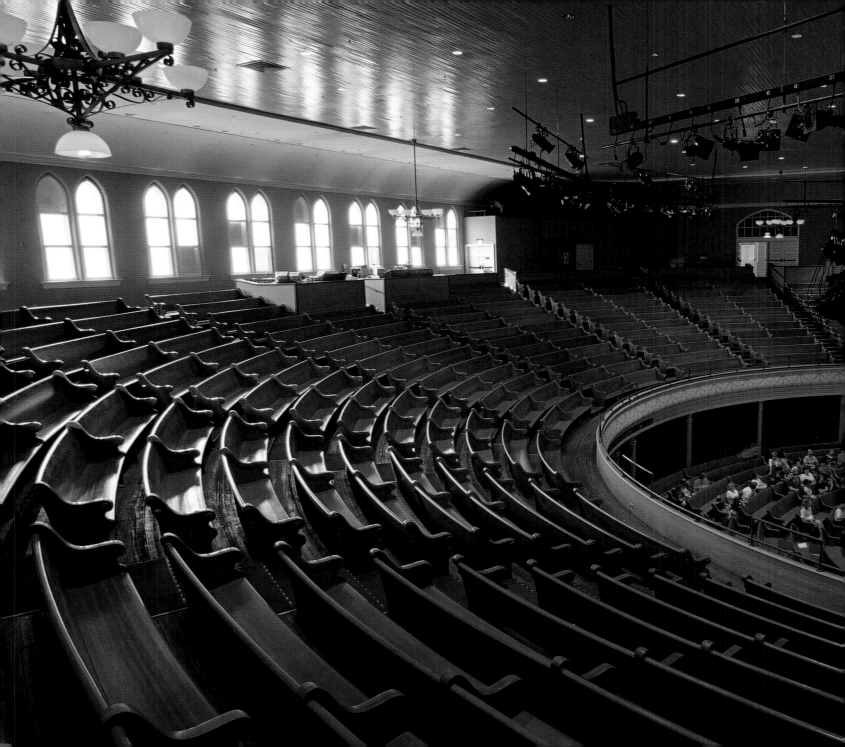

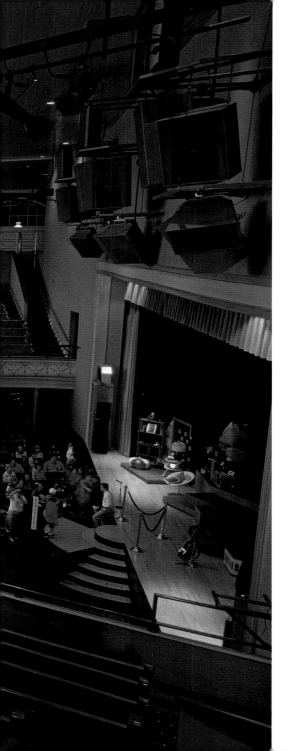

LEFT AND BELOW: The historic Ryman Auditorium opened its doors in 1892 as a church built by Captain Thomas Ryman and was the first home of the Grand Ole Opry. In 1994, the Ryman was renovated and now hosts such musicians as James Brown and Sheryl Crow.

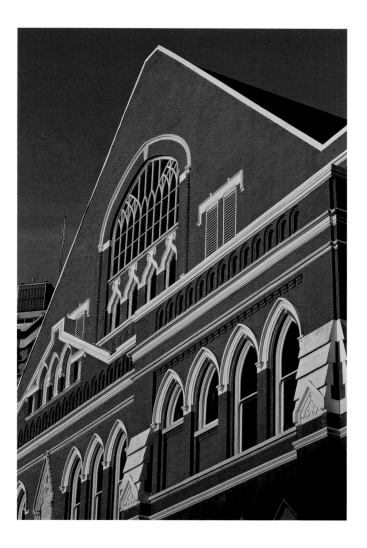

RIGHT: Andrew Jackson purchased The Hermitage property in 1804 as a place to escape the travails of public life. He initially called the estate "Rural Retreat," but then changed it to "The Hermitage." Tours of the mansion and outbuildings are offered. Pictured is the restored dining room.

BELOW: A path winds up a hillside to the walls of Fort Negley, a stone fort built by the Union Army after the 1862 capture of Nashville. The city was transformed into the Union's major supply depot for the Western Theater of the war. Today a visitor center offers exhibits on the fascinating history of this Civil War site.

FACING PAGE: Part of Metro's Park and Greenway system, Shelby Bottoms is an 810-acre park with ten miles of trails that feature scenic overlooks, interpretive stations, and seven rustic bridges. The Cumberland River Pedestrian Bridge connects Shelby Bottoms with the Two River Park and Stones River Greenway, completing a total of twenty-five miles of bike lanes and greenways from downtown to Percy Priest Dam.

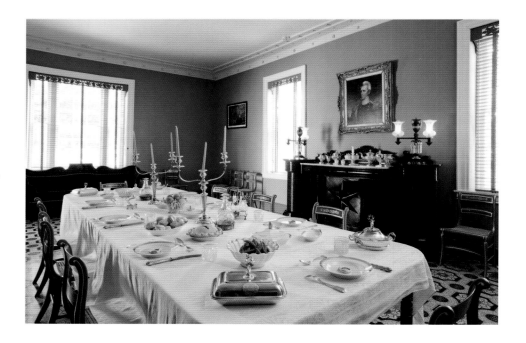

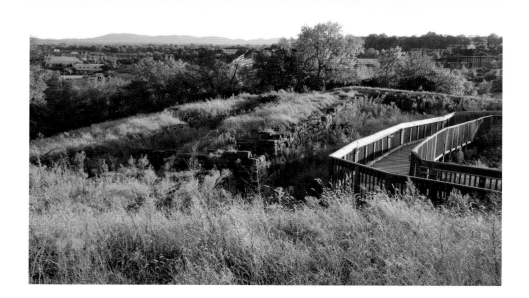

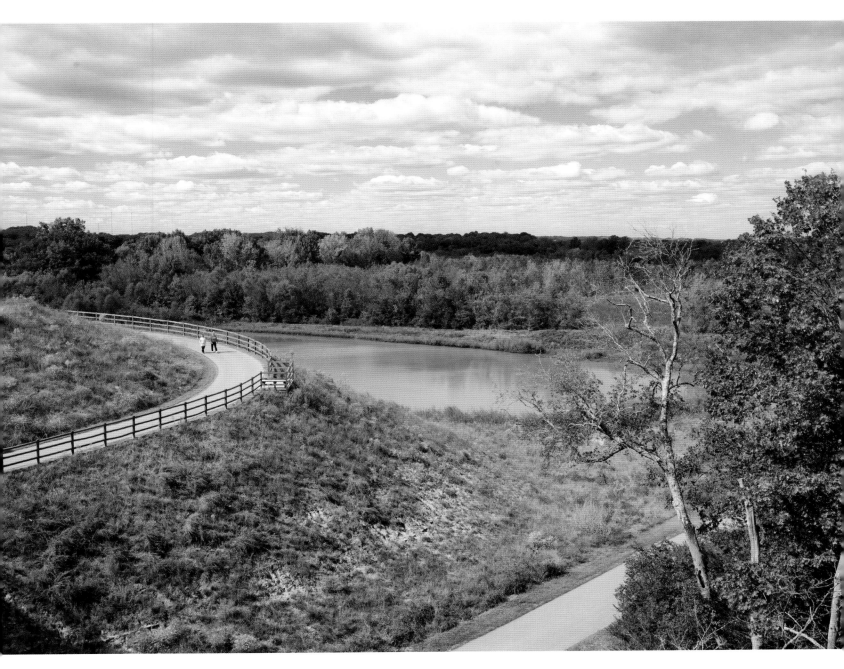

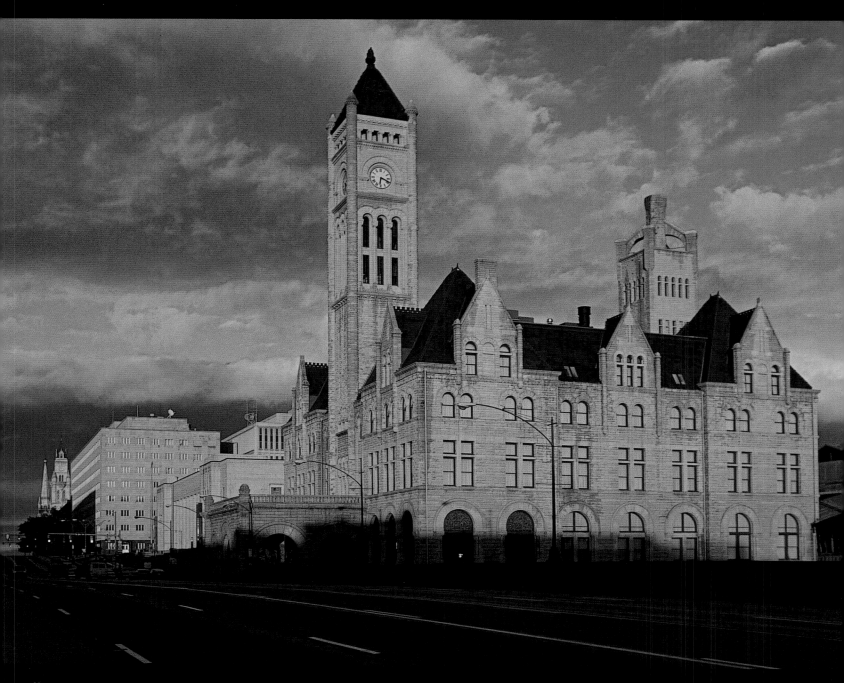

BELOW: A vivid sunrise silhouettes Jubilee Hall, the first permanent building on the campus of Fisk University, which was founded in 1866. The Victorian Gothic building was designated as a National Historic Landmark by the U.S. Department of the Interior.

ABOVE: Emmons H. Woolwine of Nashville and Frederic C. Hirons of New York won a competition in 1935 to design the new Metro Courthouse. Completed in 1937, this art deco masterpiece is still in use today.

LEFT: One of Nashville's most beloved landmarks, Union Station opened in 1900 and experienced its heyday in the 1920s. Today, the historic structure is home to the Wyndham Hotel and the four-star Arthur's

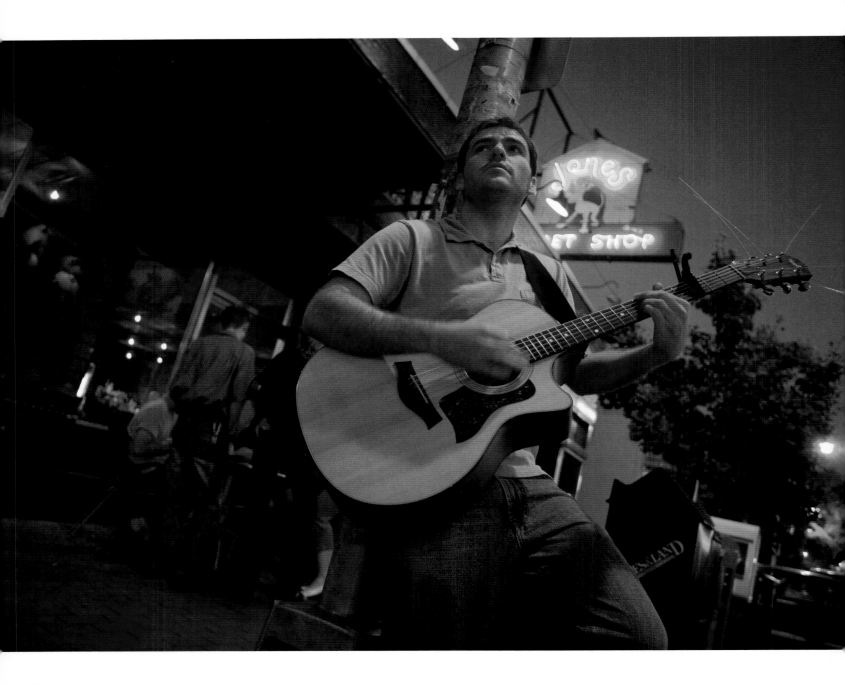

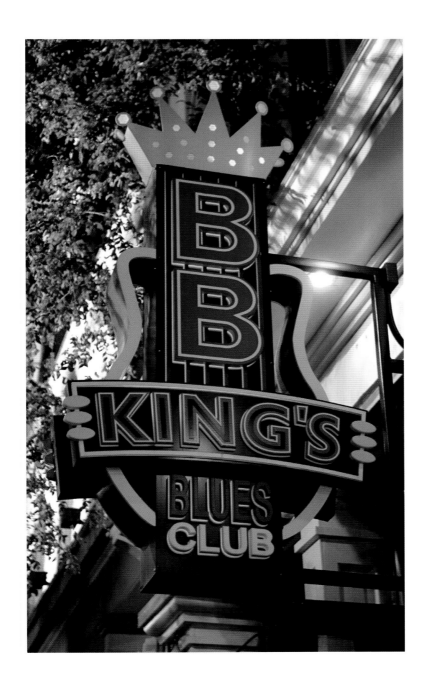

LEFT: BB King's Blues Club in downtown Nashville offers live entertainment and Southern culinary delights. King even plays a few licks on his guitar Lucille on occasion.

FACING PAGE: A street musician brings blues music to pedestrians in Hillsboro Village.

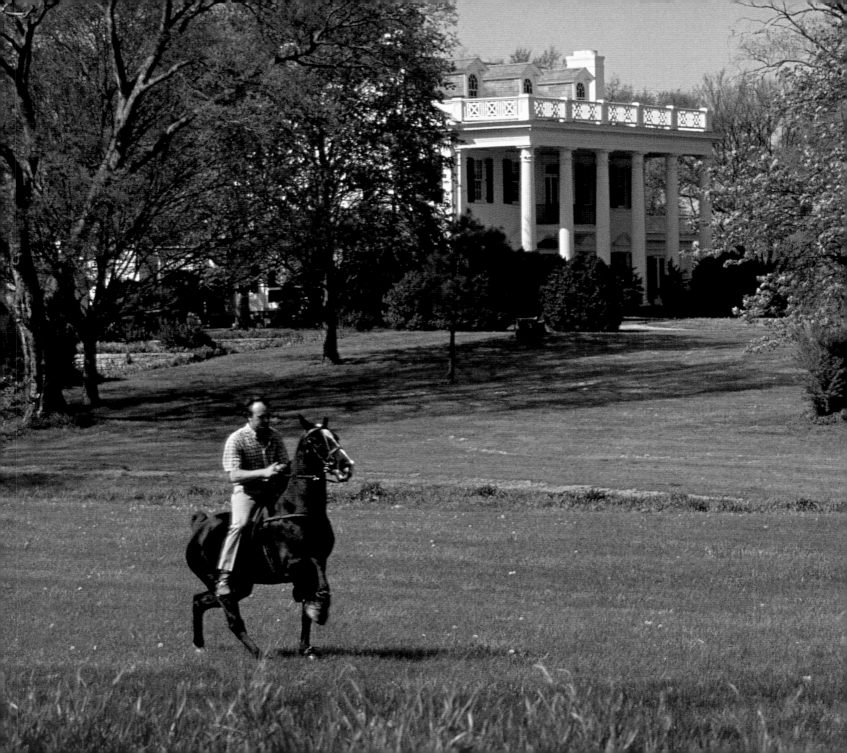

LEFT: Horse farms dot the landscape surrounding Nashville. Here a trainer is exercising a Tennessee walking horse on the Haynes Haven Farm in Spring Hill.

BELOW: A young man practices his violin on the campus of Belmont University, which has close ties to the music industry and is nationally known for its music business program.

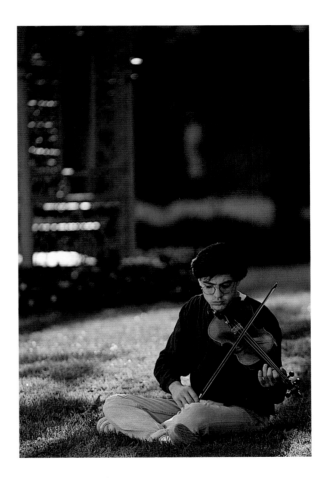

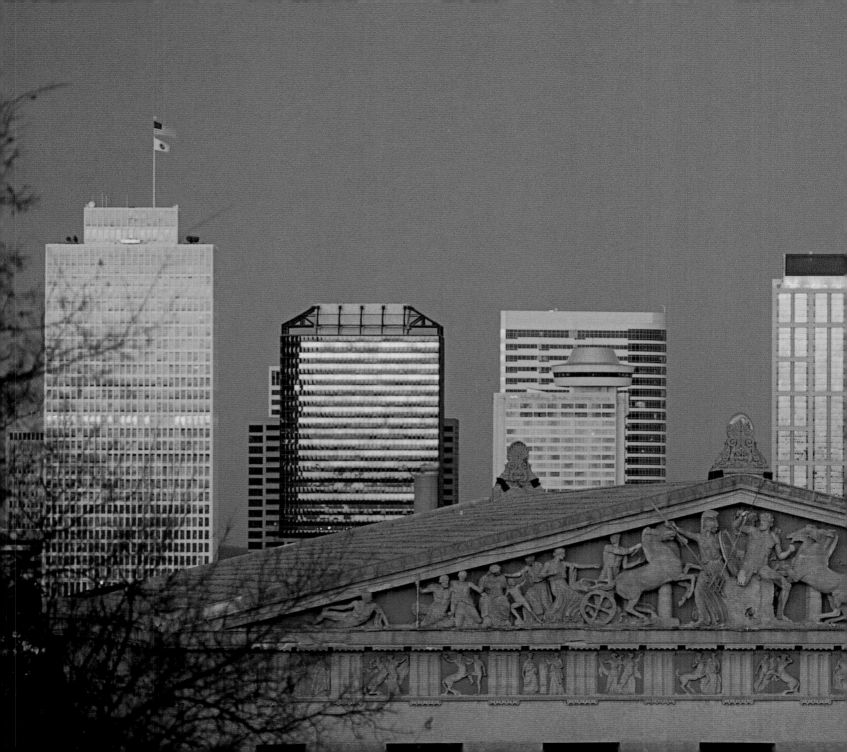

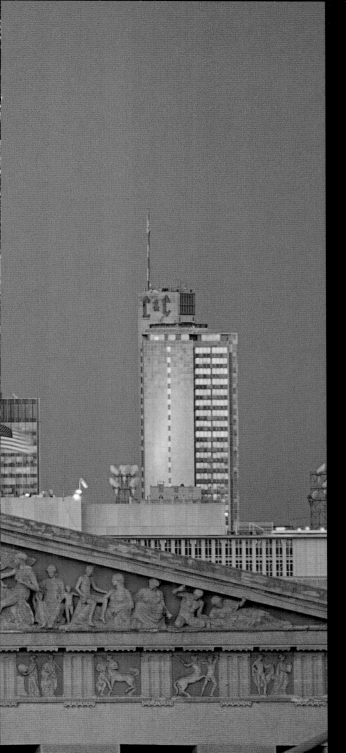

ABOVE: Sunset casts this intricate cornice of a Second Avenue Victorian building in reds and golds against an azure sky.

LEFT: The ancient architecture of the Parthenon contrasts with the modern structures of Nashville's skyline, all gilded by the setting sun.

RIGHT: Each year, Opryland presents "A Country Christmas," a holiday celebration featuring nearly two million Christmas lights, lavishly decorated trees, an outdoor nativity display, carriage rides, and live entertainment.

BELOW: Nashville's War Memorial features *Victory*, created by sculptors Belle Kinney and Leopold Scholz. The sculpture honors those lost in World War II. Behind it is the Tennessee Building, a state office that was formerly the national headquarters of American General Insurance. Nashville's War Memorial also has an event center and a military museum with exhibits pertaining to America's overseas conflicts, from the Spanish-American War through the World War II.

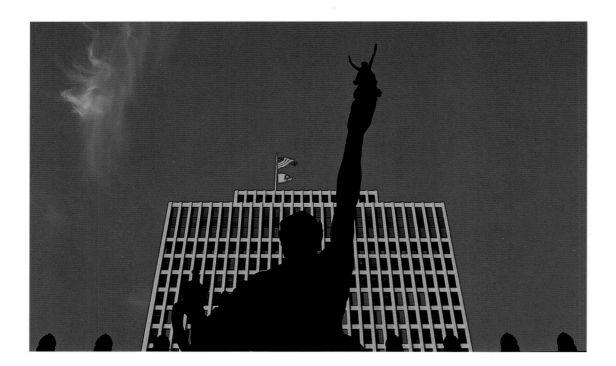

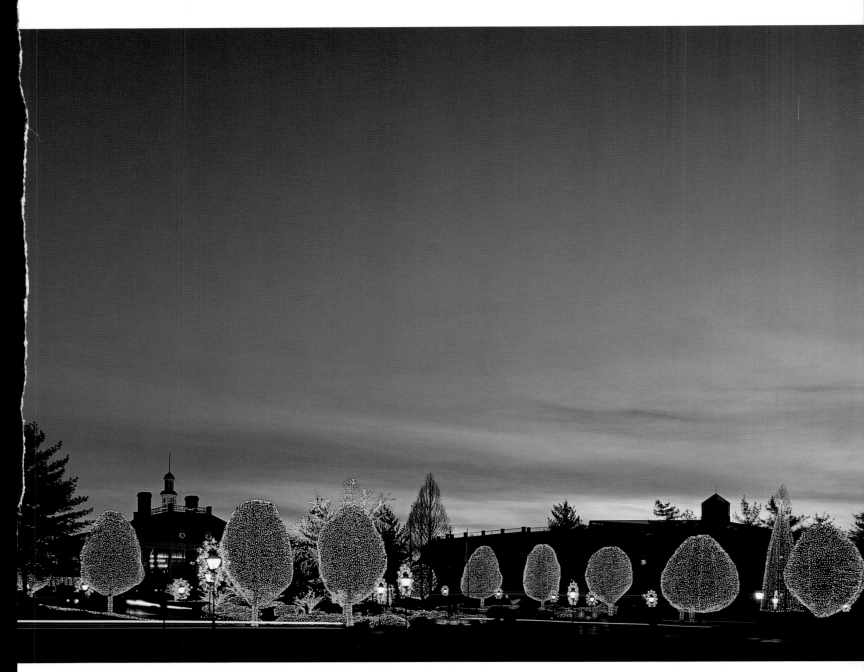